Janette Ayachi
Callie Gardner
Jane Goldman
Iain Morrison
Tom Pow

Introduction

Fiona Bradley

In a leaflet published in February 2020 I wrote of the Fruitmarket as inhabiting 'a space of in between, in which we unravel and ravel (to misquote Louis Aragon's *Paris Peasant*) our old building and the warehouse next door, making the dream of an improved and expanded Fruitmarket more and more of a reality every day'. At that time, we were several months into the building project that eventually lasted from September 2019 to July 2021. We had conceived of *Writers' Shift* as an imaginative way to document the project, and it turned out to be a key part of it, a way to help us chart that space of in between, to define the gap between the past we were trying not to cling to and the future we hardly dared to imagine.

The five poets who put in such a shift for us were asked to work together and with Fruitmarket staff on a guided process of writing to record what we optimistically termed 'our year of change', reflecting on our past and extrapolating new directions for the future. As with any creative commission, the poets took hold of this brief and made it their own.

I had thought that maybe what they would do would be a poetic equivalent of time-lapse photography: written snapshots of moments along the way that would come together into a miraculous whole, rather like the building itself. As it happened, of course, the way was fraught with Covid, and the poets weren't able physically to be in the building as often as we would

have liked. And probably they wouldn't have done that anyway: if I know anything as a curator it is not to rely on artists to give you what you think you want, but instead to rejoice that they might show you something you never imagined you could have.

Rather than concentrating primarily on the changes to the building unfolding in the present, although those are certainly threaded throughout their work, the poets seized upon the Fruitmarket's archive. It was an extraordinary gift to have their five different perspectives on the Fruitmarket's history, and the history of culture in general, when its future – and the future of culture in general – had to be taken on trust, given the precarity brought and unearthed by the pandemic.

The poets delved into the Fruitmarket's past with an enthusiasm that helped us re-embrace and re-understand it ourselves. They showed us how important the past is to the future, how to bring the past with us as we change. Not in terms of resistance to that change, but rather as a figuration of backstitch; a stitch that starts by going backwards in order to move forwards with confidence, sewing the strongest of seams in the face of whatever the future may bring.

Fiona Bradley is Director of the Fruitmarket, Edinburgh

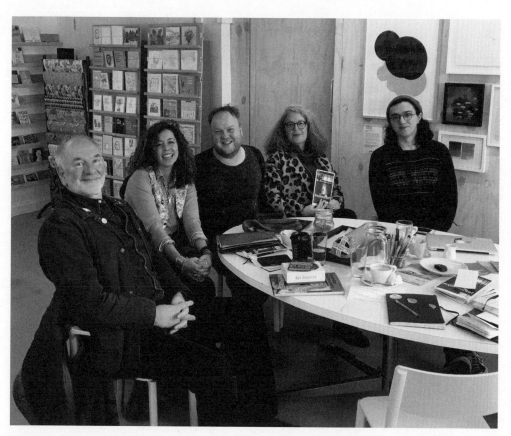

From left to right: *Writers' Shift Poets*, Tom Pow, Janette Ayachi, Iain Morrison, Jane Goldman and Callie Gardner at Fruitmarket's Bookmarket, Edinburgh, November 2019.

Nothing is Written in Stone: the plans and realisations of *Writers' Shift*

Iain Morrison

These thoughts begin in Summer 2021 in a sea-smelling room of a Cold War military base on the Isle of Lewis at the furthest northwest corner of Scotland. To move any distance on this island is to encounter the materials of past building left starkly in the landscape. Weathered structures range from homes vacated within living memory whose scraps of linoleum show through thin soil, to tumbledown shielings abandoned in the summer pastures, and monumental stones and cairns that have stood in place for millennia. All have been pillaged over the years for new work. Each ruin waits to learn from passing time whether its remnants will be repurposed, cleaned up, or allowed to sink for a while into the peat that itself is sculpted by generations of cutting for fuel. To say that nothing is written in stone has the lie given to it by Lewis' fluid topography: here even the stone that serves in cliché as the best hope for a fixed substrate to hold our or others' written words shows evidential swirls of flux and instability. Though these gneisses are some of the oldest known rocks in the world, such an outlier status highlights their proximity to vanishing back into the earth's mantle.

 The particular reused building I'm writing in, since its decommission as part of a Royal Air Force base, has been a restaurant, and now is a home,

bookshop and Airbnb. Layered and improbable, it's a suitably complicated proxy site from where to ask questions about what five poets and the wider Fruitmarket body have made of the recent time while our gallery building was being recreated within an expanded footprint hundreds of miles away in Edinburgh. If these residues of previous builds are archives of a sort, holding traces of and clues to past habitation, the business that brought me to this island attaches to the Fruitmarket's own archive in the more traditionally understood form, one with boxes of musty paper and files of expired correspondence. An emissary from the present-day organisation, Partnerships Curator on the current Fruitmarket team, I am engaged in re-writing or more simply 'righting' something that has been awaiting correction since 1975.

Before I explain, step back with me to the Summer of 2019. Then, the Fruitmarket was in the process of closing up 45 Market Street in readiness for a major renovation project that had been more than 10 years in the planning. A 'Fruit Market Gallery' had been created on the site in summer 1974 when the Scottish Arts Council took possession of one half of the former Rankin's fruit and vegetable market. By the time we headed into our fifth decade of presenting art in changing, free to access exhibitions our building, notwithstanding the contribution of Richard Murphy's 1991 renovation, was beginning to fail us. We risked losing the confidence of partner institutions whose trust in our ability to look after it enabled us to secure the art we showed in exhibitions of international standing. The organisation's activity had increased over the years as had our visitor numbers, so more space and better facilities were needed. This was about to be achieved through architects Reiach and Hall's plan to reconnect our existing building with another part of the original market space, which since the '70s had been run as a nightclub.

In that July of 2019 parts of the building were already being taken out of public use, to fill up with boxes, equipment and accumulated miscellany as we began to sort and clear. *The Annotated Reader*, Ryan Gander's and Jonathan P. Watts' exhibition as publication, with rows of ringbound texts a visitor could take away, had been welcomed into the lower of our two galleries while we awaited the signal that our building contractors were ready to start work. Artists Janet Cardiff and George Bures Miller had arrived from Canada for the last in a series of extended stays to finish making *Night Walk for Edinburgh*, a digitally immersive film and real-life encounter with our neighbouring Old Town streets that through August was to be the first off-site project of our closure period. The information room just off the upstairs gallery had become Cardiff's and Miller's temporary production office. The former nightclub next door, already empty for two years, had been stripped out to its bare walls so that we could see just

how exactly it might transform to accommodate our hopes. And we'd formed a partnership with Waverley Mall on the other side of the railway station our buildings hover over which gave us space for temporary offices and Bookmarket, a public space for our bookshop and some additional programme activity.

It was against this backdrop of busy decanting that I invited the poets Janette Ayachi, Callie Gardner, Jane Goldman and Tom Pow to join me on *Writers' Shift*, a project conceived to commission new work written from the shifted perspective offered by the Fruitmarket's temporary closure. In asking five poets to write in whatever ways we could of the Fruitmarket's past, present and projected future, the project took inspiration from a solo writing residency I had undertaken in 2018 at Southampton University's John Hansard Gallery. On visits spread over a year I had written about that gallery's move from a campus site to a new city-centre building. The Fruitmarket's Director Fiona Bradley had supported me to make time for this residency and afterwards she asked if I would put together a writing project for our own forthcoming transition period. Realising I'd find it challenging to take on alone the weight of writing about the organisation I'd worked as part of since 2010 I devised a structure to allow dialogue between a range of voices. I would curate the *Writers' Shift* project from within, writing alongside a group of co-writers.

The invited poets held, like me, their own pre-existing relationships with the Fruitmarket that *Writers' Shift* could expand on. Some of our eyes and ears had been visiting since the first days of the Fruitmarket in the 1970s, and each poet brought capabilities and experience equal to the proposed task. Ekphrasis – writing from or about visual stimuli – was part of our toolkit, but none of these writers was likely to limit their poems to description within a sealed frame of reference. This hand of poets could use the Fruitmarket's archive as an imaginative route into the commission with more liberty than academics might feel, bringing our own histories and experience into play as sources too.

I'll introduce the poets' aptness for this commission, as it appeared to me. Janette Ayachi's poems are packed with rich, visual imagery. She has worked for and spent a great deal of time in galleries. Her poems know how to bring personal, often sensual experience into tension and dialogue with artworks and cultural infrastructure. Callie Gardner's book-length poem *Naturally It Is Not: A Poem in Four Letters* (2018) marks out their skill in handling manifold references and an ability to sustain dazzling thought over lengthy forms; the breadth of possible content here would play to those strengths. Making no distinction between her academic and creative activities, Jane Goldman writes with unabashed desire to communicate information that challenges received histories, in poems that rhythmically rally and energise us, often working

to uplift other women's achievement and experience. On my Southampton residency I'd produced a book of poems *Moving Gallery Notes* (2018) and now in *Writers' Shift* was keen to mine a personal admin hoard I thought could enable me to write interestingly about an organisation from an insider's position. Tom Pow showed an empathetic ability to reanimate marginalised historical voices in his collection *Dear Alice: Narratives of Madness* (2008) which takes on the patient records of the Crichton Asylum for Lunatics. Another of his books, *Concerning the Atlas of Scotland: And Other Poems* (2014) grew multi-dimensionally from a six-month residency in the National Library of Scotland's maps department.

I met with these poets individually to introduce the project and to explore with them whether it would indeed be a match to their interests. Each was enthusiastic and by August 2020 *Writers' Shift* was constituted. As we began to come together as a group, Pow named us 'Shifters', which struck me with a pleasing, conspiratorial sense that we were all shiftily up to something, and which I loved even more when I learned that the dictionary defines 'shifter' as 'one who plays tricks or practices artifice'.

I intended *Writers' Shift* to run for one full year, starting just before Market Street closed its doors and finishing shortly after we had reopened, as scheduled, in July 2020. Supported by a calendar of activities to guide our progress, we poets would realise our commission during the renovation period.

The activities in my plan were to begin with a hard-hat tour of our building site. Then we would meet with Tom Day from the University of Edinburgh who had been supporting my colleague Ruth Bretherick to organise and digitise our exhibitions archive, entering catalogue information onto a database while marshalling and packing corresponding archive boxes. In July 2019 Bretherick was going on maternity leave imminently, but in Autumn Day

Writers' Shift poets site visit to the new Fruitmarket Warehouse, Edinburgh, August 2019.

would be fresh from this period of immersion in our history and able to excite the poets with an overview of the archive's contents, directing them to areas likely to be of interest. He could share discoveries he'd made of good places to look for information related to the Fruitmarket in other institutions' holdings, notably at the Scottish National Records Office and the Scottish National Gallery of Modern Art. In November 2019 the poets would debut some of our early work on *Writers' Shift* at a public reading in Bookmarket which would be the Fruitmarket's contribution to that year's Book Week Scotland.

In Spring 2020 I hoped to host Nazneen Ahmed, my successor as writer in residence at John Hansard Gallery, on a visit to Edinburgh. She has expertise in helping organisations to examine their use of language and I'd proposed to her that the two of us run a workshop with the Fruitmarket's staff and board to introduce them to the *Writers' Shift* poems and encourage their own creative responses. Ahmed would give a public reading of her own work during her visit supported by readings from the *Writers' Shift* poets. I aimed to support the staff's creative writing by leading follow-up workshops, these doubly serving as welcome contact time when some of the Fruitmarket's team would be working off-site or on reduced rotas. Here my timeline became more speculative but I hoped to be able to return to Southampton on a field trip to give a reading there with my *Writers' Shift* co-writers. Throughout the year I would watch for other opportunities to share the writing as they arose, and leave space for new activity generated by the poets. Final outcomes I would leave unfixed so that the project itself could generate what it needed, though it seemed likely there would be a closing event and possibly a publication or publications once the Fruitmarket had reopened.

Writers' Shift did follow this provisional itinerary closely enough during the second half of 2019. The hard-hat tour broke the ice on the project, introduced the group to each other and led quickly to poems from Pow and myself. The Book Week Scotland event on 20 November gave us a welcome first taste of enthusiasm for the project from a Fruitmarket audience. On a morning at the end of that November the poets met with Tom Day. That this session at Bookmarket fell slightly later than I'd planned meant that Day was met with specific enquiries to respond to as the poets were already familiarising themselves with the Fruitmarket's past programme via the database. Later that day we poets arranged our common Google Docs, ones where we shared our writing between ourselves, into three seasons: Winter, Spring and Summer. There was a sense of resetting the stage ready for a second act of writing to begin on the Spring document.

Then from the start of 2020 the shape of *Writers' Shift's* realisation began to differ markedly from anything intimated by the plan of scheduled activity. As we picked things up after the Christmas break, Covid started to dominate the news. At the point where we were about to book travel for what would have been her March 2020 visit, Nazneen Ahmed and I paused to

see how things developed. That pause quickly segued into an organisational shutdown for the Fruitmarket. The building work which was well underway now halted. We closed up Bookmarket and began working from home.

Writing continued, but our seasonal Google Docs soon became increasingly out of sync with the year's calendar as the project was informally extended. Any *Writers' Shift* travel plans fell away. When pandemic restrictions allowed, I was able to give the poets access to materials they requested from the Fruitmarket archive, with requested boxes brought from off-site storage to Bookmarket where they could be consulted behind closed doors.

The workshops I had envisaged leading for Fruitmarket's staff and board took place on Zoom where it was simple for the poets to introduce themselves directly. Between June and November 2020 each poet shared their work along with writing prompts designed to encourage my colleagues to add writing to another shared Google Doc I set up for them. That document contained all of the lead poets' finished *Writers' Shift* poems for the staff and board to read if they wished to take a deeper dive into the project.

In October 2020 we released a digital publication called *Timesheets* that contained a poem from each of our poets along with a brief overview of *Writers' Shift*.

The poets worked towards a new goal of finishing our written work by November 2020. That month Book Week Scotland came round again and we held an online event called *Hidden Archive*. With commissioning money from Scottish Book Trust and the other poets' enthusiastic support, I invited Shola von Reinhold to join our line-up that night. Von Reinhold's novel *LOTE* (2020) thrillingly tracks its black, queer protagonist's attempts to uncover fugitive traces of a black poet within a contemporary art archive. For *Hidden Archive* they used the Fruitmarket records to research our history of showing artists of colour.

By the time *Writers' Shift* reached its finishing line the five poets had worked together over a period of eighteen months, meeting or being otherwise in touch for discussion and support. In our work collaborative writing had happened occasionally, quotation and echo more frequently. Each of us had

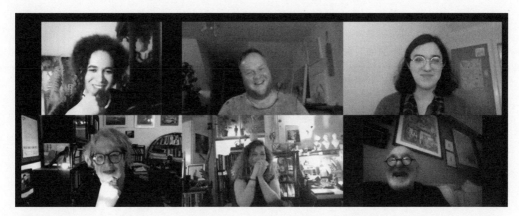

Clockwise from top left: Shola von Reinhold, Iain Morrison, Callie Gardner, Tom Pow, Janette Ayachi and Jane Goldman, *Hidden Archive* online event for Book Week Scotland, November 2020.

written in our own way of the life in which the Fruitmarket and its programme is tangled, and conversely of the Fruitmarket in which life is entangled.

Included in this book is most but not all of the writing *Writers' Shift* produced. The volume of our combined output demanded some editorial selection though I've striven to represent the range of what we worked on. The nine poems reproduced here from Janette Ayachi recover through memory and imagination experience of personal encounters with art works by Fred Tomaselli, Louise Bourgeois, Hiroshi Sugimoto and other artists, or they pull us back to take in social, even societal activity within and surrounding the gallery. Callie Gardner's compressed poems tease subtexts from anodyne materials in the archive. After a standalone poem written from their Berwick visit, a sequence of five numbered poems follows in which Gardner uses contractual clauses as a witty structuring device broad enough to hold their probings of the legal underpinnings of the art market, their language experiments with found material, and a closing lyric. Jane Goldman's poems, even a seemingly throwaway John Chamberlain ekphrasis, are underpinned by meticulous research. Goldman scrutinises the ownership of sites that the Fruitmarket's programme has occupied. Her two longest poems foreground two remarkable women, exploring Louise Dick's and Jill Smith's relationships with their art practice and with the Fruitmarket. My poems represent the texture of work within an arts organisation: sometimes comedy, sometimes anxiety or just working through lists to make a programme happen, and sometimes blessed to be in conversation with extraordinary artists and their art. My last poem goes to the archive to look at reviews of simultaneous exhibitions from Jean-Michel Basquiat and John Cage held at the Fruitmarket in 1984. Tom Pow's poems drill into the fabric of the building, adding bits on, imagining new uses, and in his attention to how the Fruitmarket exists within its hyper-local neighbourhood Pow reminds us of the universal aspects of community relationships. His poems here are always finding ways to connect us to people and to other places.

And from the wider Fruitmarket staff, in these pages each lead poet is introduced with a drawing by Kate Livingstone that responds to a quotation from their work. Also included is a selection of writing from the workshops for the staff and board.

Shola von Reinhold's presentation from *Hidden Archive* has been transcribed and is presented followed by a transcription of the conversation which happened between the poets and von Reinhold at that public event. I'll also flag here an interview between all the *Writers' Shift* poets and poet and editor Shehzar Doja that appeared in *Gutter* magazine issue 24 in Autumn 2021 and which at the time of writing is available to read for free on *Gutter*'s blog.

I've outlined *Writers' Shift's* planned shape versus how it happened, and I've given an overview of the publication you hold in your hands. The next pages expand on my dual experience as both Shifter and curator and I hope they open up the project further for you too.

'Naturally the gallery has forgotten more than it remembers', this statement came back to me during lockdown from a reading Maria Fusco had given at the Fruitmarket in October 2014 as part of 'Words, Objects, Actions, Art', a panel event hosted within an exhibition of work by Jim Lambie at a time when we were thinking with reference to Lambie's *Poetry Club* (a venue in Glasgow that doubles as a work of art) about archives in their relation to happenings and liveness. Fusco held our complete attention as she intoned about the traces of past exhibitions, of past visitors, within the walls around us. The thought she framed was of the physical gallery inspirited by an accreted consciousness, and I remember a shiver shared as she voiced to those of us breathing within its internal spaces an idea of the gallery's choosing out of necessity to forget 'those who've done it harm'.

 Willie Doherty touches on similar territories of collective memory and trauma response in a poetic piece of writing 'Some Notes on Problems and Possibilities' that appears in the Fruitmarket publication for his 2009 exhibition *Buried*. My *Writers' Shift* poem 'Aftermath' adopts an epigraph from these words of Doherty's and is based on notes I took at a panel discussion, one Doherty participated in, that I attended with Fruitmarket colleagues at the Edinburgh International Festival in 2017. The panel considered the role of the arts as truth bearers in post-conflict societies. 'Aftermath' synthesises the language of the event as it worked through difficult questions such as how to prepare space for all parties, winners and losers alike, to tell of their histories, and how to create structures that allow irreconcilable narratives to co-exist within official record:

> dividend exhausted cohesion are exhausted
> images are exhausted come to in a process
>
> to indulge there's only so much setting
> aside that is sustainable the words
> are exhausted

A feeling of the impossibility of adequate remembrance easily attaches to any work that draws from the archive, an archive being by nature of its composition an always contested formation. Jacques Derrida's book length essay *Archive Fever* (1995) was present from early on in *Writers' Shift* discussions and you'll

find it occasionally referenced and cited in these pages. Derrida tells that within the Greek etymology of the word 'archive' he finds the word *archons* meaning the men who were gatekeepers of the archive's contents and their houses where this gatekeeping was enacted. Having been formed through human decisions on what to include or leave out and therefore inevitably compromised in integrity from the start, any archive may then also, like the Fruitmarket's, survive 'damp, fire and periods of institutional neglect' – these frank words taken from a holding page on Fruitmarket's own new website in September 2021 hinting at further lacunae which are introduced over time into a putative full record.

Yet I take inspiration from the reparative approach author Shola von Reinhold took when we invited them to join *Writers' Shift* for *Hidden Archive*. Von Reinhold stated that in their event preparation they moved away from the idea of creating a fictional response to the Fruitmarket's archive, wary of visiting potential violence on the very real artists of colour within the Fruitmarket's historical programme. They instead chose to 'momentarily resurface' some of these artists in a brilliant, reclamatory talk centred on *From Two Worlds*, an exhibition first presented by the Whitechapel Gallery in 1986 and subsequently toured to the Fruitmarket – the full, impressive list of artists was Tam Joseph, Lubaina Himid, Gavin Jantjes, Sonia Boyce, the Black Audio Film Collective, Shafique Uddin, Saleem Arif, Denzil Forrester, Franklyn Beckford, Sokari Douglas Camp, Veronica Ryan, Zadok Ben-David, Houria Niati, Zarina Bhimji, Rasheed Araeen and Keith Piper – who the publicity leaflet cited with ingenuous broadness as coming 'from a wide variety of cultures spanning Africa, Asia, the Caribbean and the Middle East'. The archived exhibition leaflet tells us that of these artists 'now living and working in Britain, all of them draw a common inspiration from the reconciliation of the two worlds to which they belong.' Von Reinhold explores what it may have meant for Black audiences to see these artists shown in Edinburgh at that time as they undercut the exhibition's reductive parcelling together and consider how the artists might have chosen instead to position and present themselves.

Von Reinhold's concept of momentary resurfacing may also speak to some of the methodologies arrived at by the poets during *Writers' Shift*. The writing in this book offers a prolongation of such acts of resurfacing, and a thinking space in which recorded chronology and ideas of linear history are troubled and productively confused. I take my lead here from thoughts von Reinhold quoted from American writer and scholar Jordy Rosenberg, taken from a conversation they'd had with him at The White Review's online event 'Writing in the Absence of History' on 28 October 2020:

> Some archival work has a presumption that if a body can be found, then a subject can be recorded. But the thing about history is that it doesn't move in a linear fashion, it doesn't move always in a legible way, and we can't assume that bodies that we find in this past are

legible precursors to our contemporary forms of subject, our contemporary forms of subjective. There are aporia, there are huge historical gaps that exist and so we don't always want to encounter the archive as looking to establish.

This lights up for me the strength of appointing poets to lead this writing investigation. Gardner noted in the discussion between us writers which followed von Reinhold's talk that 'we were all able to draw something different out of the archive that a more academic-historical method might have missed, sort of panning randomly – not randomly, but with our own kind of tool, with our own set of interests and the things that we were attuned to pick up'.

To each of us reading the archives in our unique particularity, certain subjects were, to use Rosenberg's word, legible. In *Writers' Shift* none of us sought to use the archive as foundation to replicate and bolster received truths. We read and wrote between its lines, revisited, prised apart gaps and looked to create knowledge and fresh sense of antecedent activity that could offer new possibilities for what we might 'establish' in present and future programme and space.

To invite one of the poems themselves to articulate the complexity of their and our relationship to archives, I share this segment of Ayachi's 'The Architecture of Time' which draws from Hiroshi Sugimoto's exhibition of that title, held jointly at the Fruitmarket and Stills galleries in late Summer 2002:

> like the vegetable market at Waverley station
> static disappears under urban planning,
>
> things carry over, a treasure trove of archives;
> new space, old space, hoarding history
> defying the point of emptiness with memory:
> tapes, mini discs, press cuttings, boxes
>
> kept porous in structure as the fabric of the building
> stretches, reemerges, recontextualizes
>
> what do we throw away, what do we keep?

In that line 'defying the point of emptiness with memory' I'm attracted to the possibility that the unusual, deliberate emptiness of the gallery for the 'point' of refurbishment might be 'defied' by each and every one of us with a relationship to these spaces as we bring our memory, bring our sense with all its un-gatekept subjectivity into the space of the *archons*' house. *Writers' Shift* took this cleared space for the powerful acts of remembering and reassessment shared within these pages.

The politics accompanying us as we began to write in Autumn 2019 were those of Brexit. In one of my early poems, I note that a hard-hat tour of our site was taking place on 'a day in Broxtober', reflecting in language the all-pervasive parliamentary turmoil of that time. An intent to resist the loss of connection to our wider world flowered in *Writers' Shift* activity. Pow led us in staging a 'Hope Action', where cards with quotations he selected from authors Tommy Orange, Michel de Montaigne, Mireille Gansel and Miguel Torga were handed out in the streets of the city and circulated through the post to our networks. Miguel Torga's 'The universal is the local minus the walls' is a thought I've particularly enjoyed returning to, though all the quotations Pow chose resonate with an idea of borderlessness. Composite posters of Hope Action's would-be manifesto statements were displayed in and around our temporary space in Waverley Mall in the run-up to the December 2019 UK general election. The poster rounded off with Pow's added words 'we vote for these beliefs in our hearts, in our conversations and in our creativity'.

Equally outward-looking was a research trip Gardner and Goldman made that September to Berwick Film and Media Festival, as Goldman later put it 'to learn about how to write about archives', where they saw Newcastle-based artist Holly Argent's *Interleaving the Archive (Group Action with KK)*, a performance and film based on Polish performance art duo KwieKulik's work from the '70s and '80s. I recommend reading Gardner's and Goldman's Berwick poems together, 'art workers' and 'soon to be subjectile' respectively, for a comparative insight to each poet's method and to how they drew wider reference and remembrance into their written record of a shared adventure.

As we adjusted our communication to online, the Shifter poets were telling me that our project was the one thing they'd been working on that hadn't had to be cancelled when pandemic restrictions kicked in. The share of our poets' writing space that *Writers' Shift* occupied grew as a consequence and our lenses widened to take in the impact and anxieties of lockdowns. Pow's fearful imagination brought a note of the Scottish Gothic with his fantastical 'Rebirth!', a poem in which the Fruitmarket briefly becomes a plague mortuary. In 'always in the market' Gardner produced an artful cento – a poem built from quotations of multiple sources, here drawn from the poets' Google Docs – and their earlier grisly image in 'art workers' of a drink filled with tear-gas and scabs slips to being hygienically 'wiped down clean' as it's blended into a line from Ayachi's 'Waiting for Space'.

For me Ayachi's 'Waiting for Space' is one of *Writers' Shift's* breakout poems and when asked to put forward something from the project to share alongside a public information update it was an obvious choice. Ayachi's

exploded field of vision pans over the suppressed life of the plague-bound city in scrolling shapes she describes as jawbones. Meditating on the omens of bones dug up in civic works Ayachi brings us at the poem's close to a moment of altered reopening when a 'new world […] cuts her ribbon just in time for applause'. So from Autumn 2020, on our Market Street windows at street level, Ayachi's poem was posted up alongside these words by Arundhati Roy that concluded Roy's Financial Times article published on 3 April 2020, 'The Pandemic is a Portal':

> Historically, pandemics have forced humans to break with the past and imagine their world anew. This one is no different. It is a portal, a gateway between one world and the next. We can choose to walk through it, dragging the carcasses of our prejudice and hatred, our avarice, our data banks and dead ideas, our dead rivers and smoky skies behind us. Or we can walk through lightly, with little luggage, ready to imagine another world. And ready to fight for it.

I'm drawn to the difference in this conception of being between two worlds from the one proposed at the 1986 exhibition *From Two Worlds* that von Reinhold researched. Rather than remarking upon divisions and re-marking them, Roy offers a vision of what we might actually do to deviate from ingrained patterns of historic inequality.

In a typically quiet moment during one of the periods late in 2020 when we could tentatively reopen Bookmarket between lockdowns, I clocked a book that had been sitting on the unshopped shelves: Chaédria LaBouvier's *Basquiat's Defacement: The Untold Story* (2019). Partnering her 2019 Guggenheim exhibition, the study explores the history and context of *Defacement*, Jean-Michel Basquiat's painting reacting to the death of Michael Stewart, a Black American killed by the police in 1983. In 2020, we faced the knowledge that not enough had changed since Basquiat made this raw act of remembrance. Going through the national newspaper reviews (all from white reviewers) of the exhibitions Basquiat and John Cage made for Fruitmarket in 1984, I laid the contrasting statements about each artist and their work side-by-side to assemble a poem, 'Things the reviews said about'. One of the only articles that actually quoted Basquiat's voice recorded him describing one of his works in the exhibition: 'That little line, they're cops, American cops – they're around a lot, you know?'

In his acknowledgements in the exhibition catalogue which accompanied that 1984 exhibition of Basquiat's paintings, then Director Mark Francis thanks 'the staff of The Fruitmarket Gallery who have worked under great pressure to bring this project to fruition.' See Goldman's 'ON GROWTH AND FORM

(FIBONACCIS FOR LOUISE DICK)' for a poem that celebrates one of the gallery assistants who served at the time of Francis' directorship. One of my goals with *Writers' Shift* was to encourage the present staff team, those who would be on the receiving end of such thanks today, to take some space in writing to explore their relationship with and contribution to the Fruitmarket's work. Many of us use writing as part of our roles to make the gallery 'happen', whether it's taking notes at meetings, applying for funding, processing invoices or in the array of ephemeral electronic communications that compose the diet of the contemporary cultural workplace. I hoped that *Writers' Shift* would afford colleagues permission to play with a temporarily unproductive relationship with this material.

A writing prompt of Gardner's for our staff and board workshop sessions was to work from the seemingly innocuous admin materials we all had access to. This turned the camera on the minutiae of our work processes. That probable understatement 'under pressure' in Francis's staff thanks is the sort of clue to hidden intrigue that Gardner's attentive work is so good at picking up on. They talked entertainingly in our project interview with *Gutter* about how parts of the Fruitmarket archive's 'fossil record' of faxes and letters find people likely not saying what they mean or carrying out tasks with what seemed to be 'the most extreme reluctance'.

Drawing on correspondence between the Fruitmarket and other institutions Gardner had fun with these subtexts, reorganising this material to comic effect, such as in the passive-aggression latent in the repetitious sub-claused lines in the second of their numbered poems:

[2.3.1] export formalities
[2.3.1] packing material/labour
[2.3.1] telephone and petties

This poem extracts its language from tense exchanges between partner institutions preparing to host a 1989 touring solo exhibition from Belgian artist Marie-Jo Lafontaine, one whose cost was growing exponentially out of control. Gardner tightens the screw in a further poem iteration to:

[2.3.2.1] formalities export petty
[2.3.2.2] telephone labour

Gardner's exploitation of the pun on 'petty' as in cash and 'petty' as in attitude leaves me to ask smilingly who amongst us has not exported petty telephone labour when formalities have held us back from saying what we may have wanted to?

In this book's selection of the Fruitmarket staff's writing, Elaine Kilpatrick's reworking of some paperwork from the National Import Relief Unit is an example of how Gardner's liberatory mischief was taken on. Other writing

from colleagues responded to Pow's storytelling, my expanded note-taking, Ayachi's ekphrasis or Goldman's encouragement to make communal word hoards as shared materials for further poems.

The staff section of the book closes with a poem Natasha Thembiso Ruwona wrote in response to the exhibition of Senga Nengudi's work that was present in the Fruitmarket from March to May 2019, around the same time the idea of *Writers' Shift* was forming. I first read these words of Ruwona's on the handout for a performance night *Each body has a use, has a use* they co-produced during that show, with the title also derived from their poem. Its perspective pushed me to reach in *Writers' Shift* towards a structure that supported as many voices from within the organisation as we were people.

I stated at the beginning of this piece that I was gathering my thoughts while on the Isle of Lewis and that I'd travelled there on archive business. One of the most affecting explorations of the *Writers' Shift* project is unfolded in a magnificent long poem of Jane Goldman's that reintroduces us to Jill Smith, who in 1975 as Jill Bruce was one of the Fruitmarket's first exhibited artists and the first woman in our programme. The former military building I was writing from is found in the village where she now lives. Her own house reclaims the air force's former transport office around the corner. In Summer 2021 Goldman and I had come to meet with this woman in the landscape that she and her work so fully inhabit.

Goldman's poem visits Smith's experience in the time flowing from her Fruitmarket exhibition. I won't rehearse overmuch what the poem so effectively communicates other than to say its starting point was Goldman's research-keen eyes noticing that what to her clearly had been an exhibition of two people's work was listed in our archive as a 'solo exhibition', one credited solely to Smith's then husband Bruce Lacey. We are back therefore in the domain of Derrida's treacherous *archons* and have a perfect example of an occasion where, as in Rosenberg's point quoted earlier, we are in danger of replicating an act of erasure if we look to the archive as a reliable ground on which to establish. The contemporary newspaper reviews of 1975 treated the exhibition the same way, as a man's solo effort. Again I'm thinking of Basquiat's side-lined voice a decade later, though here it's Smith who ghosts the edges of press interviews with Lacey. Within her *Writers' Shift* poem on Smith and Lacey, Goldman also valuably audits the early years of the Fruitmarket's programme for its representation of women, and there are more fascinating leads here that I hope others will follow in future creative and academic work.

Smith has been teaching me about less vicious, more virtuous circles of reinforcement. In the books she writes to document her epic walking works,

particularly *The Callanish Dance* (2000) which charts ten years of repeat visits at key points in the calendar to a complex of sacred sites on Lewis and Harris, she writes of such repetition as a deepening of the circle. When she goes on to talk of an experience of time that is more spiral than circular in nature, with change inevitably built in as we reinscribe a shape, it's tempting to think of the spiral shapes carved into the rock of some of the Neolithic sites she is drawn to. Following Goldman's *Writers' Shift* work, we are extending an invitation to Jill to return to the geographical space of our building nearly 50 years since she was last there to see with us how the circles have widened in a new part of the Fruitmarket's timeline.

As we moved around the year's circle the saddest experience of *Writers' Shift* was to learn, in the week that the gallery reopened, of the sudden death of one of our dear Shifters, Callie Gardner, at the age of 31. They had visited the reopening Fruitmarket at the start of July 2021 for one of our preview days and were pleased with the results of our remaking, particularly appreciating our new archive room. Daunted at my coming editing task, I asked Gardner then if they had any ideas about how we should publish all of this unbounded *Writers' Shift* work. They said with wry humour that they were rather glad it wasn't their problem to work out. With characteristic self-reliance, Gardner had in fact made *SHIFT ING* (2020), a zine comprising most of their poems from the project. They shared a download link to *SHIFT ING* in the Zoom chat at *Hidden Archive* and the folding structure with its tightly cropped edges is reproduced in facsimile here. The diligence with which Gardner prepared and finished their work has made it possible to share it with confidence, alongside that of their colleagues.

Gardner had a great respect for Bernadette Mayer, a New York poet most recently familiar to Fruitmarket audiences as one of the publishers of Lee Lozano's language works in the *o to 9* magazine, pages of which we displayed in 2018's *Slip Slide Splice*, a solo exhibition of Lozano's work. One of Gardner's touchstones was Mayer's writing experiment 'Work your ass off to change the language & don't ever get famous.' As Gardner said in the editorial to the thirteenth issue of *Zarf*, an 'experimenting poetry' zine they edited from 2015–20, to follow Mayer's advice 'means a writer has to be neither a hobbyist nor a professional but something completely different, and we can't do that alone'. I find this commitment to collectivism echoed throughout the *Writers' Shift* poets' work, as here in Goldman's 'IT FEELS LIKE A WAY TO LOVE' reminding us that the best alchemy our public space serves is the creation of communal from individual experience:

a belly of collective moves

in daily artistic practice
her free advice solo knows

it is never solo she moves
with street dialogue into

performative space carries
singular concerns of passers

by into collective body
movements

In the context of *Writers' Shift*, Gardner's method offered visibility to anyone's contributory work towards the Fruitmarket's organisation, in our history and in our present. As in the whole body of their achievement, in their participation in *Writers' Shift* Gardner constructed space I would characterise as offering empathy, kinship, recognition and dignity. Part of their legacy is to have shown us where we can help each other out in what might be small acts, but ones that augment and amplify individual energies in what may add up to world-changing consequence.

One of the earliest of *Writers' Shift's* poems, Pow's 'The Fruit Market – Extension', faces up to the fickle nature of sites we inhabit and their inherent resistance to tethering by any of our human designs:

space has innocence, anonymity.
We cup it and let it go
like a fly we've failed to capture.

We trap it best by building around it,
turning space into *place*
 as here –
though any enclosure
carries history, its own
or one memory or imagination
may give it.

On the Hebrides, Goldman and I made a pilgrimage, accompanied by Jill Smith, to The Island of Bad Council on North Uist, a location Gardner had visited and written about (replacing 'council' with 'counsel') in the 'summerletter' section of their book *naturally it is not*. Here, at yet another historically complicated site where three tiny sheltered islands are connected by causeways to the shore, a broch was built two millennia ago then later occupied by Vikings before being adapted in late mediaeval times to a square tower house run by clan chiefs and factors. It is from this last period before ruin that the islands' 'bad council' epithet stems, and the grisly story is worth looking up. It was odd in the sunlit, tranquil emptiness, to think of past consciousnesses moving about that place. As we read it out, Gardner's 'summerletter' seemed a divining rod through which the past was touched on as repeatable or avoidable history. I noted the ambiguously humorous tone of this poem's 'definition of progress: / doing the same thing over and over / and expecting a different result'.

On those island summer days, Goldman and I found ourselves reflecting dryly on poet W.H. Auden's famous observation that 'poetry makes nothing happen'. Our trip, and *Writers' Shift* as a whole, seemed proof this wasn't the case; here we were after all, in conversations and places we never would have been had it not been for Goldman's poem. Yet, we shouldn't expect a firmly held sentiment from Auden's aphorism, coming as it does from his elegy 'In Memory of W.B. Yeats' (1939), a shifty poem which moves in blithe self-contradiction through suspiciously insouciant lines that continue '[poetry] survives / In the valley of its making where executives / Would never want to tamper' and end by attesting that '[poetry] survives, a way of happening, a mouth'.

This gathered content generated by *Writers' Shift*, what it sees and reports, points up again and again that the sites and valleys of making, whether of poetry or art, if we are to differentiate at all, are places constantly requiring defence and rebuilding. It is a steadying thought to be reminded of this at a time of our successful emergence after self-reinvention. Wonderfully, the Fruitmarket prevails, in stone, in brick, in wood, in poured concrete, in its people, in its mission.

I offer congratulations to all my fellow poets, and thanks to poets and colleagues alike for trusting and entrusting me with the time and resources to make this exploratory project happen. You have in your hands a book of wonderful writing that I know will be a talisman of the Fruitmarket's working and thinking life in years to come. I hope it helps you as it has helped us, and more personally has helped me, to pick up place again in our continuing life.

Iain Morrison is Partnerships Curator at the Fruitmarket, Edinburgh

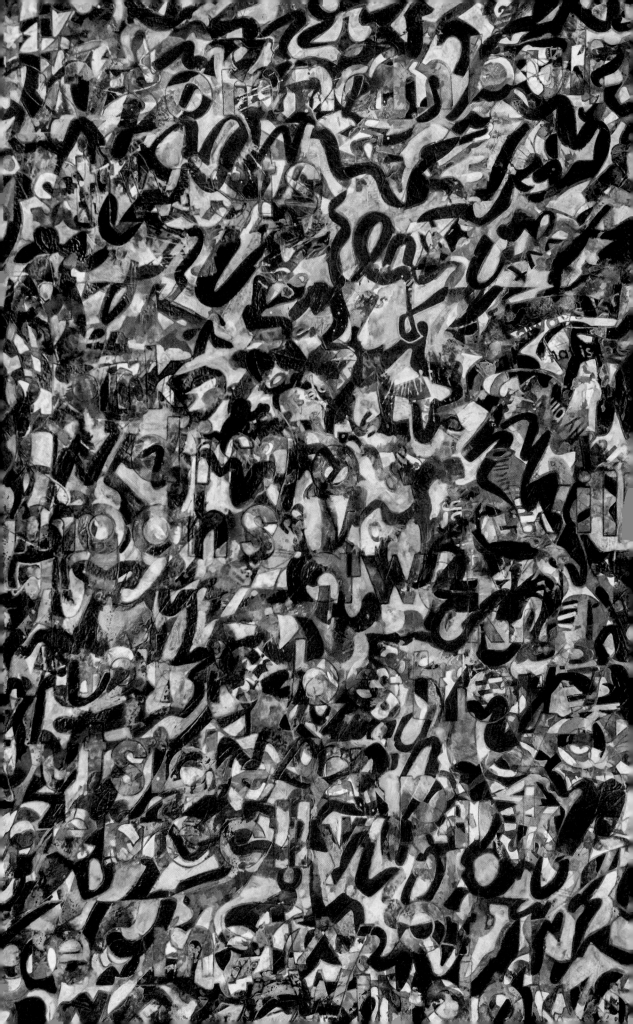

Janette Ayachi

Previous page: Kate Livingstone, *Somnambulist Twists*, 2021
Ink and acrylic on paper, 42 x 60 cm
Title taken from Janette Ayachi's poem, 'I Keep Giving Myself Away'

Fruitmarket Café

Outside the world tells us to hurry up
but the art inside asks us to slow down;
shows us that we have time…
time to sing when we wash the dishes
time to rummage through life's archives
when the minutes succeed each other
melt into the infinite charm of living,
words leak cypher script across the sternum of sunsets
and of course I am rattling a mute dolphin in you now
as you relax into your own dulcimer
only hold story for when you trust me to listen,
days seem hourless, seamless across these café floors.

Censor of touch, deceased spark,
I search around with my eyes pinched tight for the fuse,
old Edinburgh blush, your delicate skin
falling in patches of decadent decay,
but we tend to our own gardens
snip the last lily before winter grabs her first
keep the flute music for the woodland bear
now prayers are as paralysing as an epidural.

I am here today to stop thinking about you
my new date arrives in a gust of leaves
the train tracks cough-up their gutturals
meanwhile, the ocean babysits our love.

Molecules of autumnal rain
crease against the gallery window
under the paladin helm of the sky
where loneliness sails the mist
and thunder threatens lanterns on the bridge
to bleat out conundrum and aphrodisiac stars.

We all become as intrinsic as myth here
dancing against the squall
in a riot of embroidered Fruitmarket light.

You turn the corner, canting out of the sun
as shapely as the larynx

a clove of silver asylum
against immaculate sighs
littering the café corridor now
walls are made out of windows
my heart an ancient gong,
a sanctuary against the grief of fulmar
crumbs tessellate in union of hot palms
that hold glossy textbooks
almost plastic and perhaps water resistant
Basquiat's graffiti is magnified
under the ocean of a mint tea glass.

The intrinsic pleasure of looking at art
is utterly involving, a dip out of dark,
a dramatic invocation in the afternoon
imprinting desires within the body.

Loner

After Edward Hopper

Edward Hopper: The Formative Years was a 1980 travelling exhibition from Whitney Museum of American Art that gravitated towards the Fruitmarket in 1981, showing that year from 28 February – 4 April.

I love being alone, there is a certain higher power invoked in the solitary, space for the leaky and chalky mind to stay undissolved. People around me in a buzzing penumbra of their own voice, their spirit diluted against the other; groups are chaotic and claustrophobic, impossible to navigate, couples or one-on-one is just too much steam pressure and gage. Yes, you can mark your existence against each other where the pizza dough burns in the background, romance is guzzled, you can share platters, secrets kisses and conversations but keep self-scripture and desire for when you wake and your lover is still sleeping, when the bats fill the gutters and the neighbours' sighs fill the crevices and an abundance of children's snores fill corridors and last nights' preordained supper fills sinks and you fill the bath and fill yourself under a bounty of stars when nothing moves but the wind willing and ready to carry you across planes. Like small boys who become brave soldiers, with their warrior glitter and spot-lit scars, the candle melts into disappearance: true love follows. I have an irrational hatred for first-year art students; they are as miraculous as lapis.

'I Keep Giving Myself Away'
After *Fred Tomaselli: Monsters of Paradise*,
31 July – 3 October 2004

Making art is making something to last
– a published book or a printed portrait,
who thought immortality a selfish wish,

to stay intact and write forever
like this thick of landscape
held together with epoxy resin
waiting out centuries
fashioned accordingly
like a fixed sniper on a rooftop
probing countries for truth
losing count of lovers,
the dead becoming never born at all,
tracking the vanity of skin and bone
on ambrosia carried by Olympian doves
learning, learning, new discoveries
under the apothecaries' hiss
of nature's sedative
on loop as lungs stampede
toward last breaths, last kisses.

We are already waiting
for inherent wisdom,
and trusting our capacity to hold
all of the world's damage
as moss and lichen blanket-out names.

Listen to the infusion of stars
in this bounty of eternity,
matter cannot be created
or destroyed
it simply changes form.

Cells and sinews of the body
becomes a technology
wrestled from the gods,
atoms and letters of the alphabet.
Monsters of Paradise

scan the grass with your torches
let confetti caress your hair
or let yourself freefall
into a sea of hands,
the somnambulist twists
of dark disco moons
will always know
what is best for you.

Then more fruit, Bacchus,
and let us uncover the hieroglyphs,
you see, I follow my own self prophecy;
wine cellars, dips, ghosts
under the staircase,
perennial flowers and women
who direct invisible orchestras
with hands over tapas dinners.

Outside a perfectly pink sky
and a geometry of windows
telling me limbo doesn't have a language
it is the silent moment you decide
if you would jump
from a burning ledge
or embrace the flames;
a spider web of carnival beads
to show for bravery, to dress the sky.

Faces on the big screen
prowl in plasma, loosen their static
into the room like an estuary moon
hirsute in its thrill to stun
and stammer the senses.

What else is there?
Other than what we have already collected.

Unmet desire:

so in minutes left alone
I set my lenticular gaze
on the women with eyes
that morph into mirrors.

It was like a keyboard error in my mouth;
a tapping, unsticking, then tapping,
the tendrils of my tongue feeling for font.

I once cheated love the same way
a secret gives up its magic
and becomes a piece of information
once shared.

Seduce me, then show me
the mechanics of that seduction.
Drugs and music helps,
says the artist in Brooklyn
claiming his era defective,
painting with pills, leaves and insects.

I was just about to graduate,
catapult from the swan pond to the capital
for a dose of culture of course,
to rinse a head of dusty Chaucer,
dress in the clean bones of modern art instead.

My lover was as exotic and cryptic
as a Libyan Sibyl
guiding me through the exhibition
chasing this image projection…
how much can you control?
 what compliments? what insults?
unfiltered, full frontal, full throttle, foregrounded attention
 a flair for enormity perhaps.

I tail away from sunsets
like Neruda's cloak
oared against
some Catalonian coastline
and the ghosts outside our window
don't dare to reach our dreams.

Ghazal: Change of Heart

These kerosene cities felt at the pip of my heart like a little spat-out thunderbolt
prone to tip & capsize at any moment of transient shapeshift to catapult change.

In a fetishistic age of communication; ghosts are familiars, spectres approaching
holding their breath what would they say on exhale; wise voices, reflectors of change.

I have never seen you angry? 'It happens about once a year & it's spectacular!'
we hack at bricks & mortar, keep finding more rooms, more air, more art; breach lenticular change.

I want to be as majestic as a mountain, said the building, in utero of sky
enacting suicide on the tracks' edge, involvement of the dark unseen, our hero; change.

And the fish knew not to find out how quicksand was tolerable enough for touch
love was lost then found again, resuscitated from the mineral & ample stuff of change.

Serenading midnight strays, the Fruitmarket on stilts, pilgrims at the station disrobed
who can resist this attunement to nature, culture, a craving dedication for change?

The Architecture of Time

After Hiroshi Sugimoto: The Architecture of Time,
2 August – 21 September 2002

In downtown Tokyo, destroyed
after the second world war,

snapping up abandoned theatres
where white light is anchored

like the vegetable market at Waverley station
static disappears under urban planning,

things carry over, a treasure trove of archives;
new space, old space, hoarding history

defying the point of emptiness with memory:
tapes, mini discs, press cuttings, boxes

kept porous in structure as the fabric of the building
stretches, reemerges, recontextualizes

what do we throw away, what do we keep?
(at the forefront of contemporary culture)

the postmodern timeless space of a gallery
 – like airports, is a place of transit and transcendence:

The moon pulls up a pew at our table
I want to gag the tick of the clock
 with some jealous zephyr.
You came in on a tornado
dismantled me
 when I was steadied on a crest of a wave
of Summer romances, new soul contracts.
It's easy to brush up against that vanguard
 to misread the mathematics
 we celebrate by saturating ourselves
 with midnight margaritas instead,
 wet our thick accents of bone lintel
 to dig through new damage in crevices
 of the body, do I disrupt them,

such meagre mornings,
always missing half expected kisses.
What a bash against the abdomen,
 a bruise like a puddle of petrol
 left behind where the heart once parked
 and left its keys in the ignition,
 turned off all alarms.
 Water is grated from the clouds this morning,
 apparent sunbeam saws through the teeth of the sky.
 When travelling I never know where I am
 and I never get anywhere, pull up a deck chair,
 feel that you contain enormities at home.
 Why doesn't your heart bleed for me?
Amphitheatre of blue
bronzed torsos, clouds of sand dust
 burst from the sea bed under construction,
 hermit sea crabs stir like startled soldiers
 woken from the trenches of time.
 Moss grows behind the pavement
 forests pasture born in the cracks of gutters.
 I am a sunset in the desert
 taking the fire home
before darkness sets to freeze,
see how its tourmaline muscles flex,
 how much simple beauty tramples
 away the worst stung heart
 with a nettle of possibilities at play.
 My love has no face now
 where to begin
 when you only know that
 you have an end;
a xylophone circuit spun situation
 Someone is about to move in,
 inhabit, take hold, make space;
 or someone has left, to get lost,
 leave things behind,
 clues combed with desire,
long nights freckled with stars. I keep them,
love letters from the bottom of Swiss mountains
 what lies beneath is a deliberate architecture,
 come visit my tomb with flowers anytime.

Waiting For Space

So much of Edinburgh's history still lives on
in the streets and cellars, hearts and homes
in brushwork, engravings and dusk
the world's loot and treasure
sanctioned under glass
what do we hope to heist
from what is left behind?
I am haunted by omission
a hound of crumbling memories
this year has been wiped down clean;
what should I do, write against the erasure?

Humans are backing into their natural habitat
after a drought of touch and comfort
deliriously lit with the intimacy
of their inside joke.
Haircuts and pints
we are recognised again
greeted by waiters
dressed as Chernobyl scientists
so what is it we are craving now
as we all smile in mirrors with our eyes
a hurricane of illegal raves, rebellious serenades?

When I close my eyelids long enough the phosphene
makes tiny neon nooses to play with
taking the lead in bison of flight
as if they are constrained
ahead of time
a viper strike
like magic and life
is a series of mutations;
big beast birds with boneless wings
the things we meet as first humans arriving
how long from diagnosis to death, the sick ask as we wait.

Tram works dig up skulls of plague victims
graves desecrated for new tracks plaid
a shawl of four-hundred year
old bodies coughed up

for the blurry eyed
after a pub crawl escape
staggering home to meet the
insurmountable fullness of a charnel pit
and the number of pharmacologic suicides
gulped by prescription behind closed doors.

The zoo lions out-roar traffic; how old are your bones?
Excavations sigh; how heavy is your breath?
Why are all the limbs piled
separate from the heads?
Disjointed skeletons
Medieval deposits
matching radius
alongside side part of a fin
of a male adult sperm whale
splashing in quick to be broken
into an explosion of pieces at the harbour
remnants of a cannonball, residents of the long past
offshore we drown our antics, say our prayers for the land;
the unarmed forensic charm of the worm under the microscope.

Our garrulous Nor Loch chanting about where she belongs
with the stark harmonic voices of a choir of witches
weaving hair underground Waverley Station;
it is difficult to not get lost in the grief.
'You are a peacock;
a bird
that is
so hard
to catch
with its tail open'
she says but I was only illustrious until I fell in love
then so many bore my eye as feathers in their cap.
Should I go back to sleep and play small
to appease all the malignant egos
or should I just speak up
in my ancestral fury?
With most flights
grounded
there is less space
on soil for outstretched arms
hydraulics left without maintenance
nesting birds move into the mansion wings

tiny titanium flaws as fuel sits full in its slack tanks
giant silica sachets wedge into engines, a slow corrosion
catching humidity and forgiving the neglect of use
dockyards of aluminium beasts bathing
on their bellies and athletes' biceps
left to rot; chemtrails are on halt
world's bird's-eye view paused
but nature works its way
round the quiet runway
like a visiting priest
practising before
a burial ground.

 I hold my own heart
 in the vine of my reflection
 I find the inner pool of glitter rising
 and under mud-tossed-on storm clouds
 I could see Mars crafting its craters;
 a floating and gear of floating
 – roam and fear of roaming.

Lucien, I wonder what we will listen to
when we twitch in eleven years?
I invent a love for him
a simulation of love
a simulacra of timeless ideal
as she loiters around giving off gloom
her head always falling too heavy on my lap
like a tire-ridden stem too weak to support its flower
I am happy stuck in hell when there are haloes for sale
what is this thing that is bred in captivity; can it be trust?

Red lights
and road works
delay your comfort
of filth and noisy kisses
today you are rain talking
in Finnish at my big window
the froth up against basalt cliffs
and sometimes the grit under snow
but I wait for you, smug as shiny buttons
fondled into circles with gentle fingers at dawn
as the new world prepares us for energetic upgrades
opens her doors and cuts her ribbon just in time for applause.

(July 2020)

'Insomnia Told Me its Dreams'
Alice Oswald
After *Louise Bourgeois: I Give Everything Away*
26 October 2013 – 23 February 2014

wintery sunset struts
begin to seduce our end of the year

anonymous and untethered
like a married woman in a hotel

trying on a new expensive dress
counting her hibernation stash

where the moon takes photographs
of umbrella-pines and cypresses

in a milky setting
and offers them to her

as she finds a means for release
sleep, sleep, sleep,

outside, the radial tick of tires
those dervish transmitters

do not get into cars with strangers
yet we
let them
into our beds

we are being locked in again
alongside everything

that we have gathered in life so far;
left-over night-hours, pets, kids, books, plants, lovers & crockery

and as stray mantras introduce themselves
for the one millionth-thousandth time

i find a Louise Bourgeois exhibition programme
let slip with a memory out of a *Selected Rilke* book

like a ghost behind a shower curtain
the scent reminiscent of a last meeting
before marriage robbed her from me

"have you ever been in love?" she had asked then
swirling her finger in the air before an *Insomnia Drawing*

"i have told myself it was love at the time so i could feel it"
i replied with sincerity and an eyebrow raise

for love is not a tomb in the hurricane heart
waiting to be disrobed
there is a deep cyclone
instead
that shapes
the cloud
into a comma

i feel the snow fall from within me;
snakes and marshmallows
loins, koi fish, weave of hair,
woken right up by Bourgeois now

her spellbook of painting on top of print
bloodwork, cartilage, artichoke leaf, four-eyed forehead

fear and beauty on paper
absorbing into the room

the slipstream between past and present
fingerprint between reality and imagination

like all the girls'
eyes in the bathroom
feigning as wide as Ferris wheels
as we went deeper into the night
deeper into the Grassmarket

where insomnia leaks its dreams
of breath and touch and blinding music
lifting essence out of its heavy bones
long art gallery afternoons
to diaphanous a.m. connections
living and dead ensembles
honeymoon diaspora
red ink kisses
i have collected them all
life's a perpetual audition
of returning lovers
from the moors of our sub consciousness.

**'Love stems from the sudden urge to make permanent
what only passes by'**
 Ramón Gómez de la Serna

Art is where the multiverse lives
where parallel time movements
allow the past to still exist
future+past+present – all at once.

Timeless space of galleries
people dissociate from Time;
the pull of Life paused at their heels,
to manifest the beauty of the past
and suspend themselves away
from the frantic traffic of the truck-tug forward.
We are modelling experience. It is all sculpture.

Audiences need to feel part of the process:
 interpretation/reverie
 analysis/creativity
 deconstruction/enigma
 reconstruction/repair

Creator-Curator-Collector-Spectator-Writer Creator-Curator-Collector-Spectator-Writer

Art showcases the novelty of liberation of imagination for us all.

Creator-Curator-Collector-Spectator-Writer Creator-Curator-Collector-Spectator-Writer

The Girl and Gerhard Richter

After *Gerhard Richter: Multiples 1965–97,*
2 August – 27 September 1997

**'When people look at my pictures I want them to feel the way
I do when they want to read a line of a poem twice'**
 Robert Frank

You appeared like an out-of-focus
Richter photo-painting, a muddy exposure
and ghostly presence, blurred at the edges,
as if you were always too far away.

Like the glass rectangles
you offer mute transparency,
a hollow that reflects only its own echo.

A diffuse ochre light always surrounds us
as we dance the blur of dark day to bright night
if only I could tame expression as you do

if only I could touch you then I could confirm your essence
and envelop it the way a snowstorm closes in on a citadel.

A silicate smile, but it has always been about the mouth
singing its mineral din, sneering its head
like the shifting of the earth's crust.

The tension of a suspended palette knife
should I apply a kiss
or remove one from your lips.

Scraping away at the paint,
leaving colour to coincidence
a grey monochrome
serrating its heart to opulent colour.
A desire for you that is lost then rediscovered
illuminating truth as it distorts itself over and over
into a haunting abacus of charcoal eyes.

Callie Gardner

Previous page: Kate Livingstone, *Assembled*, 2021
Ink and acrylic on paper, 42 x 60 cm
Title taken from Callie Gardner's poem '3.'

art workers

u.i.o. holly argent / KwieKulik / angela y. davis
berwick-upon-tweed 21.9.19

slime, waters, and dust
propaganda made-to-order
closely analysing our own old records
'we need more action, not more
work.' she follows her own fragmentary
records, collages them as we watch.
the train will be arriving on platform BUS
and it is on the rail replacement service
that i read angela y. davis' 'Communist Women'
Her own opposition to fascism ran deep,
for she herself had already been victimized by
its terrible ravages. the reproductive labour is recorded
also; he gives out the money but not
to the children. it is time to expose the conditions.
art workers: why are we poor?
well! many of us are not poor
i had a dream my wounds were finally healing
at a wine reception and i looked down and my drink
was actually liquid tear gas, and also it was full of scabs;
being in competition with one another makes
for an awkward environment, a bad odour
(think rotting flesh) *charged with*
'speaking without a permit', she was carted off to jail
with her father troubling cones make open works
into social klein bottles. home/work/politics –
if your invisible kinships are non-recyclable –
but it all gets thrown away anyway –
so i am putting more and more of my
shopping back. she sits in front of the camera
and reveals the lump on her breast, like a
tiny christ in an 80s pietà. it's unclear here
who 'you' and 'me' are. *my sisters whom I can see*
in the night and on the walls of the fortified city.

1.

[1.1]

[1.1.1] here's how arts become
the extrastate, allow it to reproduce
itself in horrendous mentality.
adding a feminist 'h' in the second
position to cthulhu is beside

[1.1.2] the point. in the republic,
plato imagines an omphalostical
origin for the ruling class whereby
all their education is a dream.
in fact they grew beneath the earth

[1.1.3] and their weapons formed there
with them. we could scope, i suppose,
an analogy where radical pedagogy is
by luckless psteud forgot; it opens its pages
and dumps its contents on their head.

[1.2]

[1.2.1] suppose – you need a new artist
for a project – you need someone from
an underrepresented group – but also
talented and to your taste – such people
don't emerge from any community (!)

[1.2.2] they are formed in the earth, given
memories later of [1.2.2.1] family,
[1.2.2.2] schooling, [1.2.2.3] inspirations,
[1.2.2.4] influences, [1.2.2.5] travels,
[1.2.2.6] and [1.2.2.7] hardships,

[1.2.3] and thus the quota is fulfilled.
the ground is those other anonymous world cities,
and autochthony is the free-ish movement
of educated and wealthy bodies come
what may. so where does art come

[1.3]

[1.3.1] from? where do these people get their
interest and preoccupations? of course
they are found in the tender wombus
of mxther earth hirself. and they come
with [1.3.1.1] histories, [1.3.1.2] contacts,

[1.3.1.3] but [1.3.1.3.1] no friends
[1.3.1.3.2] or [1.3.1.3.3] lovers,
[1.3.1.4] and walk out of the mound
with their powers intact. [1.3.2] the foregoing's
fancy – [1.3.3] but [1.3.3.1] i [1.3.3.1.1] saw

dreamer bbs memerging from every mouth,
[1.3.3.2] took a fee for helping someone
plagiarise their way into an m.f.a.,
[1.3.3.3] legislated and financialised myself
into writing things [1.3.3.2] i [1.3.4] really disagree with.

[1.4]

[1.4.1] plato had one thing right, which is
that poets should be banned from
the ideal republic ([1.5.1.1] if you spend
any time with them you may know this is still
a sore point after twenty-five centuries)

[1.4.2] because they tell lies. poets
will say that they tell the truth, but
that is just what a liar would say. certainly
poets would not be able to cwtch up
to the truth endorsed by philosopher-kings

[1.4.3] because they tend to run out of
approved combinations of words and have to
start making them up. even today
you can just about get away with this,
but it won't fly in the utopian future.

2.

[2.0.1]

[2.0.1.1] We still have customs problems for clearance of above mentionned shipment, so customs authorities wants a new fax copy of the pro forma invoice you send with this shipment for an amount of £—.

[2.0.1.2] PLEASE SEND THIS COPY BY RETURN FAX TO AVOID ANY FURTHER PROBLEMS

[2.0.2]

[2.0.2.1] MUST FLIGHT AS BOOKED

[2.0.2.2] We are equal to the influences of new technology in our industry, and are capable of producing a very professional package

[2.0.3]

[2.0.3.1] Dear Sirs.

[2.0.3.2] Please note with immediate effect we have appointed — — as our Customs Brokers. This instruction supersedes all previous instructions. Thank you for your co-operation.

[2.0.4]

[2.0.4.1] export formalities 175,00
[2.0.4.2] packing material/labour 1260,00
[2.0.4.3] telephone and petties 18,50

[2.0.5]

[2.0.5.1] I called you one day, but Lesley said you were very busy, so I did not bother you.

[2.0.5.2] Why not come to London when we begin to unpack the show on June 28/29th? I am sure it would be useful for us both.

[2.0.6]

[2.0.6.1] WE ARE CONCERNED AS TO THE FREIGHT CHARGES OF — + —

[2.0.6.2] COULD YOU ALSO EXPLAIN THE ROUTE THE WORK TOOK
BEFORE ARRIVING IN EDINBURGH?

[2.0.7] 'Cage Like' crates with structure inside

[2.0.8] TO KNOW TO RETAIN + TO FIX THAT WHICH IS SUBLIME

[2.1]

[2.1.1] We still know clearance problems
for shipment of above mentionned
shipment, so fax retains a new copy
voice of the in shipment you fix with
this amount for an copy of £—. PLEASE KNOW

[2.1.2] THIS FAX BY RETURN PROBLEMS
TO RETAIN ANY FURTHER INFLUENCES.
We fix equal to the technology of new industry
in our package, and know capable of producing
a very professional flight Dear Sirs.

[2.1.3] MUST RETAIN AS BOOKED.
Please fix with immediate brokers we have
known That Which Is Sublime as our Customs
instruction. This instructions retains all previous
co-operation. Thank you for your customs.

[2.2]

[2.2.1] I called you one day, [2.2.1.1] but L— said
you were very busy, [2.2.1.2] so I did not bother you.
[2.2.2] Why not come to London when we unpack
the show on June —th? [2.2.2.1] I am sure it
would be useful [2.2.2.2] for us [2.2.2.2.1] both.

[2.2.2] I called you one both, [2.2.2.1] but you
were very busy, [2.2.2.2] I did not bother so.
[2.2.2.3] L— unpack London, [2.2.2.4] we come to the
—th show [2.2.2.5] it would be June day. [2.2.2.6] Why
am I not useful for you? [2.2.2.7] sure it would be us

[2.2.3]
[2.2.3.1] June were useful bother to busy youth

[2.2.3.2] L-London, come, I am sure I called
[2.2.3.3] you were one to be the Why
[2.2.3.4] but I not so—us would unpack very both.
[2.2.3.5] day would not show for it. did we?

[2.3]

[2.3.1]
[2.3.1] export formalities
[2.3.1] packing material/labour
[2.3.1] telephone and petties

[2.3.2]
[2.3.2.1] formalities export petty
[2.3.2.2] telephone labour
[2.3.2.3] and packing materials

[2.3.3]
[2.3.3.1] a grumpier kilt beaned:
[2.3.3.2] o pain! tease a prolix rift;
[2.3.3.3] the plot dances on.

[2.4]

[2.4.1] WE FIVE ARE NATURALLY CONCERNED!
[2.4.2] AS IF IT WERE POSSIBLE TO LEAVE,
FREIGHTED OR CHARGED WITH MEMORIES
OF THIS AND THAT —

[2.4.3] COULD EVEN YOU, [2.4.3.1] WHO ALSO SEE, [2.4.4] EXPLAIN
THE LONGER ROUTE, [2.4.4.1] AROUND THE CONSCIENCES,
[2.4.5] THE WORK TOOK BEFORE ARRIVING IN EDINBURGH?

[2.5]

[2.5.1] cagelike crates with structure inside
[2.5.2] the inside structures of crates are cagelike
[2.5.3] i like a cage, found structure inside
[2.5.4] a fond sage, rusticated to design,
[2.5.5] defunded to a gasp the dingy, rusty case,
[2.5.6] erased desire, fed the stray pages
[2.5.7] in disgrace to a carcass fire,
[2.5.8] thus caressing a dire feast.

3.

[3.1]

[3.1.1] february 1st, 1937: the united states
opens its first foreign trade zone on
staten island, new york city. goods
could now enter this 92 acres of land
and water without being subject

to duties or taxes. ([3.1.1.1] i'm not saying
taxes are good but the more money you
have the more likely you've done something
unethical to get it, & they pay for what governments
owe any person they make suffer

[3.1.1.2] the indignity of living in a nationstate,
her existence subsumed into the seething
ceaseless mass of flag and pride, as
[3.1.1.2.1] tissue, [3.1.1.2.2] foreign object,
[3.1.1.2.3] ejecta, [3.1.1.2.4] et cetera.)

[3.2]

[3.2.1] goods in the foreign trade zone can legally be
[3.2.1.1] stored, [3.2.1.2] displayed, [3.2.1.3] assembled
[3.2.1.4] tested, [3.2.1.5] repaired, [3.2.1.6] manufactured
[3.2.1.7] sampled, [3.2.1.8] manipulated, [3.2.1.9] salvaged,
[3.2.1.10] relabelled, [3.2.1.11] mixed, [3.2.1.12] destroyed,

[3.2.1.13] repackaged, [3.2.1.14] cleaned, [3.2.1.15] or
[3.2.1.16] processed. [3.2.2] but what of my, or my lover's,
need or desire to be [3.2.2.1] stored, [3.2.2.2] displayed,
[3.2.2.3] assembled, [3.2.2.4] tested, [3.2.2.5] repaired,
[3.2.2.6] manufactured, [3.2.2.7] sampled, [3.2.2.8] manipulated,

[3.2.2.9] salvaged, [3.2.2.10] relabelled, [3.2.2.11] mixed,
[3.2.2.12] destroyed, [3.2.2.13] repackaged, [3.2.2.14] cleaned,
[3.2.2.15] or [3.2.2.16] processed? [3.2.3] we are likely to be
unfairly subjected to various laws and fees [3.2.3.1] in
the pursuit of our basic needs and sovereign desires.

4. // always in the market: a cento
composed of lines from Writers' Shift poems by Janette, Jane, Tom, Iain & me
except line 42 which is from Iain's *Moving Gallery Notes*

we need more action, not more work
to risk a hand
in bent metal somehow nettled
into an explosion of pieces at the harbour.
"oh hello, i am a poem

with a nettle of possibilities at play."
i had a dream my wounds were finally healing,
posthumous, exhumous, humus;
keep finding more rooms, more air, more art
among the headstones for a lump beneath.

it was demolished and became a car park.
there will still be good things we act like we've forgotten
i am here today to stop thinking about you
at a wine reception and i looked down and my drink
this year has been wiped down clean

"keep on looking up"
but i am at an art gallery!
a simulation of love
in your photographs
was actually liquid tear gas, and also

we can never leave as one of us is always reading a book.
i traffic in extinction too
a belly of collective moves,
revenge, and then when i was placed somehow in
the empty city

it was full of scabs
and the streets floated up to my knees
defined by this step we walk
prone to tip and capsize at any moment.
"excuse me, are you looking for the castle,

defying the point of emptiness with memory?"
she follows her own fragmentary records
to burn many incenses, isolating the right detectors

wrapped in light from leith.
"a gift shop –

i thought so."
as you relax into your own dulcimer
i am putting back more and more of my shopping;
very little prospect in this society
to stay intact and write forever.

i-i want to acknowledge we stand
not chancing the inevitable;
i expect to learn new artists' names, yet always
speaking without a permit
of an exhibition which is the exhibition.

5.

it was my job to tummyrumble,
measure out some spit,
be lost, affrayed,
among assembled
people asking it

and as the wind slapped branches
out of disciplining hands
i slept all night
the easy right
to be equipped with scans

securely bought
and soon forgot
their scattering
on the strand.

[1.3.1] from? where do these people get their
interest and preoccupations? of course
they are found in the tender wombus
of mxther earth hirself, and they come
with, [1.3.1.1] histories, [1.3.1.2] contacts,
[1.3.1.3] but [1.3.1.3.1] no friends
[1.3.1.3.2] or [1.3.1.3.3] lovers,
[1.3.1.4] and walk out of the mound
with their powers intact, [1.3.2] the foregoing's
fancy — [1.3.3] but [1.3.3.1] i [1.3.3.1.1] saw
dreamer bbs mereging from every mouth,
[1.3.3.2] took a fee for helping someone
plagiarise their way into an m.f.a.,
[1.3.3.3] legislated and financialised myself
into writing things [1.3.3.2] i [1.3.4] really disagree with.

[1.4.1] plato had one thing right, which is
that poets should be banned from
the ideal republic ([1.5.1.1] if you spend
any time with them you may know this is still
a sore point after twenty-five centuries)
[1.4.2] because they tell lies. poets
will say that they tell the truth, but
that is just what a liar would say. certainly
poets would not be able to catch up
to the truth endorsed by philosopher-kings
[1.4.3] because they tend to run out of
approved combinations of words and have to
start making them up. even today
you can just get away with this,
but it won't fly in the utopian future.

```
[2.0.1]
[2.0.1.1] We still have customs problems for clearance of
above mentionned shipment, so customs authorities wants a new
fax copy of the pro forma invoice you send with this shipment
for an amount of £—.
[2.0.1.2] PLEASE SEND THIS COPY BY RETURN FAX TO AVOID ANY
FURTHER PROBLEMS

     [2.0.2]
[2.0.2.1] MUST FLIGHT AS BOOKED
[2.0.2.2] We are equal to the influences of new technology in
our industry, and are capable of producing a very professional
package

     [2.0.3]
[2.0.3.1] Dear Sirs.
[2.0.3.2] Please note with immediate effect we have appointed
— — as our Customs Brokers. This instruction supersedes all
previous instructions. Thank you for your co-operation.

     [2.0.4]
[2.0.4.1] export formalities 175,00
[2.0.4.2] packing material/labour 1260,00
[2.0.4.3] telephone and petties 18,50

     [2.0.5]
[2.0.5.1] I called you one day, but Lesley said you were very
busy, so I did not bother you.
[2.0.5.2] Why not come to London when we begin to unpack the
show on June 28/29th? I am sure it would be useful for us
both.

     [2.0.6]
[2.0.6.1] WE ARE CONCERNED AS TO THE FREIGHT CHARGES OF — + —
[2.0.6.2] COULD YOU ALSO EXPLAIN THE ROUTE THE WORK TOOK
BEFORE ARRIVING IN EDINBURGB?
[2.0.7] 'Cage Like' crates with structure inside
[2.0.8] TO KNOW TO RETAIN + TO FIX THAT WHICH IS SUBLIME
```

[2.1]

[2.1.1] We still know clearance problems
for shipment of above mentionned
shipment, so fax retains a new copy
voice of the in shipment you fix with
this amount for an copy of £—. PLEASE KNOW

[2.1.2] THIS FAX BY RETURN PROBLEMS
TO RETAIN ANY FURTHER INFLUENCES.
We fix equal to the technology of new indust
in our package, and know capable of producin
a very professional flight Dear Sirs.

[2.1.3] MUST RETAIN AS BOOKED.
Please fix with immediate brokers we have
known That Which Is Sublime as our Customs
instruction. This instructions retains all
previous
co-operation. Thank you for your customs.

[1.1]

[1.1.1] here's how arts become
the extrastate, allow it to reproduce
itself in horrendous mentality.
adding a feminist 'h' in the second
position to cthulhu is beside

[1.1.2] the point. in the republic,
plato imagines an omphalostical
origin for the ruling class whereby
all their education is a dream.
in fact they grew beneath the earth

[1.1.3] and their weapons formed there
with them. we could scope, i suppose,
an analogy where radical pedagogy is
by luckless pstead forgot, it opens its pages
and dumps its contents on their head.

1.

[1.2]

[1.2.1] suppose — you need a new artist
for a project — you need someone from
an underrepresented group — but also
talented and to your taste — such people
don't emerge from any community (i)

[1.2.2] they are formed in the earth, given
memories later of [1.2.2.1] family,
[1.2.2.2] schooling, [1.2.2.3] inspirations,
[1.2.2.4] influences, [1.2.2.5] travels,
[1.2.2.6] and [1.2.2.7] hardships,

[1.2.3] and thus the quota is fulfilled.
the ground is those other anonymous world cities,
and autochthony is the free-ish movement
of educated and wealthy bodies come
what may, so where does art come

[2.2]

2.1] I called you one day, [2.2.1.1] but L— said
 were very busy, [2.2.1.2] so I did not bother you.
2.2] Why not come to London when we unpack
 show on June —th? [2.2.2.1] I am sure it
ld be useful [2.2.2.2] for us [2.2.2.2.1] both.

2.2] I called you one both, [2.2.2.1] but you
e very busy, [2.2.2.2] I did not bother so.
2.2.3] L— unpack London, [2.2.2.4] we come to the
 show [2.2.2.5] it would be June day. [2.2.2.6] Why
I not useful for you? [2.2.2.7] sure it would be us

2.3]
2.3.1] June were useful bother to busy youth
2.3.2] L— London, came, I am sure I called
2.3.3] you were one to be the Why
2.3.4] but I not so-us would unpack very both.
2.3.5] day would not show for it. did we?

SHIFT
-ING

CALLIE GARDNER

WRITTEN FOR THE WRITER'S SHIFT AT THE FRUITMARKET
GALLERY, 2019-2020

[4.0]
always in the market: a cento
composed of lines from writer's Shift poems by Juliette, Jane, Tom, iain & me
except line 42 which is from iain's Moving Gallery Notes

[4.1] we need more action, not more work
to risk a hand
in bent metal somehow nettled
into an explosion of pieces at the harbour.
[4.2] "oh hello, i am a poem.
with a kettle of possibilities at play."
[4.3] i had a dream my wounds were finally healing,
posthumous, exhumous, humus;
keep finding more rooms, more air, more art
among the headstones for a lump beneath.

[4.4] it was demolished and became a car park.
there will still be good things we act like we've forgotten
i am here today to stop thinking about you
at a wine reception and i looked down and my drink
this year has been wiped down clean.

[3.1]
.1] goods in the foreign trade zone can legally be
1.1] stored, [3.1.2] displayed, [3.1.3] assembled
1.4] tested, [3.1.5] repaired, [3.1.6] manufactured
1.7] sampled, [3.1.8] manipulated, [3.1.9] salvaged.
.10] relabelled, [3.1.11] mixed, [3.1.12] destroyed.

.13] repackaged, [3.2.14] cleaned, [3.2.15] or
2.16] processed, [3.2] but what of my, or my lover's,
ed or desire to be [3.2.1] stored, [3.2.2] displayed,
.3] assembled, [3.2.4] tested, [3.2.5] repaired.
.6] manufactured, [3.2.7] sampled, [3.2.8] manipulated.
.9] salvaged, [3.2.10] relabelled, [3.2.11] mixed.
.12] destroyed, [3.2.13] repackaged, [3.2.14] cleaned,
.15] or [3.2.16] processed? [3.3] we are likely to be
rily subjected to various laws and fees [3.3.1] in
pursuit of our basic needs and sovereign desires.

[4.5] "keep on looking up"
[4.5.1] but i am at an art gallery!
[4.5.2] a simulation of love
in your photographs
was actually liquid tear gas, and also

we can never leave as one of us is always reading a book.
[4.6] i traffic in extinction too
a belly of collective moves,
revenge, and then when i was placed somehow in
the empty city

it was full of scabs
and the streets floated up to my knees
defined by this step we walk
prone to tip and capsize at any moment.
[4.7] "excuse me, are you looking for the castle,

defying the point of emptiness with memory?"
██████ he follows her own fragmentary records
to burn many incenses, isolating the right detectors
wrapped in light from leith.
[4.7.1] "a gift shop —

i thought so."
[4.7.2] as you relax into your own dulcimer.
i am putting back more and more of my shopping
[4.7.3] very little prospect in this society
to stay intact and write forever.

[4.8] i-i want to acknowledge we stand
not chancing the inevitable;
i expect to learn new artists' names, yet always
speaking without a permit
of an exhibition which is the exhibition."

[3.1]

[3.1.1] february 1st, 1937: the united states
opens its first foreign trade zone on
staten island, new york city. goods
could now enter this 92 acres of land
and water without being subject
to duties or taxes. [3.1.1.1] i'm not saying
taxes are good but the more money you
have the more likely you've done something
unethical to get it, & they pay for what governments
owe any person they make suffer.

[3.1.2] the indignity of living in a nation-state,
her existence subsumed into the seething
ceaseless mass of flag and pride, as
[3.1.2.1] tissue, [3.1.2.2] foreign object,
[3.1.3] ejecta, [3.1.2.4] et cetera.

[2.4]
[2.4.1] we five are naturally concerned!
[2.4.2] as if it were possible to leave,
ΞIGHTED OR CHARGED WITH MEMORIES
THIS AND THAT —
[2.4.3] could even you, [2.4.3.1] who also see,
[2.4.4] explain
ΞE LONGER ROUTE, [2.4.4.1] around the consciences,
[2.4.5] the work took before arriving in edinburgh?

[2.5]

[2.5.1] cagelike crates with structure inside
[2.5.2] the inside structures of crates are cagelike
[2.5.3] i like a cage, found structure inside
[2.5.4] a fond sage, rusticated to design,
[2.5.5] defunded to a gasp the dingy, rusty case,
[2.5.6] erased desire, fed the stray pages
[2.5.7] in disgrace to a carcass fire,
[2.5.8] this caressing a dire feast.

5.

was my job to tummy-rumble,
measure out some spit,
be lost, affrayed,
among assembled
people asking it

and as the wind slapped branches
out of disciplining hands
i slept all night
the easy night
to be equipped with scars

securely bought
and soon forgot
their slattering
on the strand.

[2.3]

[2.3.1]
[2.3.1] export formalities
[2.3.1] packing material/labour
[2.3.1] telephone and petties

[2.3.2]
[2.3.2.1] formalities export petty
[2.3.2.2] telephone labour
[2.3.2.3] and packing materials

[2.3.2]
[2.3.3.1] a grumpier kilt beaned:
[2.3.3.2] o pain! tease a prolix rift;
[2.3.3.3] the plot dances on.

Jane Goldman

HERE TOO THERE WAS FRUIT

i-i want to acknowledge we stand
here on common land common land
bought by this city's common good fund

in seventeen seventy-six common
good funds bought land for the new town
yes the land here beneath the fruitmarket

gallery before it was a fruit market this land
became the common land where we stand
including the land here beneath this mall

yes this mall is built on common land
the station is built on common land
market street is built on common land

visit any town in scotland any town
look for market street market muir names
that denote common land in any town

in feudal times the common good funds
were protected in every scottish town
we stand here on common land

bought by the town council from the trustees
of heriot's hospital the common good fund
was and is a free fund to be used

for the common good of the inhabitants
of the burgh a free fund to be used
to build common wealth and prosperity

in a new enlightenment city a new
enlightenment city hardly are those words out
when a vast image (out of the scott

monument) troubles my sight what could
a new enlightenment city be
that is not served by a station named

for a piece of unionist fiction penned
by the ghastly incumbent of that vast
silly neo-gothic necrolatic stone edifice that looms

over common good funded common
land lurching towards bankruptcy i-i
saw it at its finest in the nineteen

nineties wrapped in scaffold and tarpaulin
truly it looked gorgeous for the only
time so sonsy so cubistic it was alive

about to fly away its tarpaulin
wings sunning themselves in
our common sunlight or flip-flapping

in our common dreich or raging in
our common rains iced by common snows
howling in our common bitter winds

the first fruit fruitmarket stood where
the station now stands the second fruit
fruitmarket stood here on this spot where

this fruitmarket pop-up shop pops up
that second fruit fruitmarket fruited for
ninety-four years until nineteen thirty-

eight then the third fruit fruitmarket opened
on market street and this site of the second
fruit fruitmarket then hosted cattle shows

dog shows car shows the ideal home shows
and the great north welly boot fringe show
starring billy connolly in the year before

it was demolished and became a car park
in nineteen seventy-three for ten years
still common good fund funded common land

i-i want to acknowledge we stand
here on common land common land
yes this mall is built on common land

the city has leased out the solus or site
since nineteen eighty-two to a string
of companies who bought and sold

the lease for millions yes millions
starting with reed publishing pension
trustees limited and reed pension trusts

limited letinvest plc
and speciality shops plc
scottish metropolitan plc

continental shelf two seven four
plc then pm limited partnership
sold it in two thousand and five for

thirty-seven million quid to david
murray's ppg metro limited
the annual rent roll then stood at

two point three million andy wightman
says the common good fund of the city
of edinburgh lets the site for a rent of

a penny a year (if asked) when in twenty-one
eighty-eight the lease runs out the common
good fund will have earned two pounds sixty

(if asked) and precisely nothing (if not asked)
the lease on the waverley mall is now owned
says google by the investment group trade

hold tradehold supported by billionaire
christo wiese has restructured itself into
a property company with an unusual mix

of uk south african and namibian assets
the joint ceo friedrich esterhuyse
said the company that has invested

in more than fourteen billion rands worth
of property can now pay dividends regularly
and can offer shareholders exposure to

a defensive mix of uk commercial
properties and a strong portfolio of
industrial properties in south africa and

namibia south africa and namibia
hardly are those words out when a vast
image of multinational global corporate

exploitation expropriation and centuries
of scotland's wealth built on transatlantic
slavery again troubles my sight

namibia means vast land vast land
namibia is not our vast land
namibia's expropriated wealth

(i-i want to ask) should not should it
underpin our common good funded
common land i-i ask this in a poem

made for the fruitmarket gallery made
crossing the first and between the third
and second sites of local fruit

fruitmarkets built on common land fruit
fruitmarkets rebuilt as the fruitmarket
gallery and the fruitmarket pop-up

it's the twentieth of november twenty-
nineteen i-i want to acknowledge
we stand here on common land

funded by common good funds
here now there is art here now
is poetry here too there was fruit

SOON TO BE SUBJECTILE

[writers' shift trip to berwick-upon-tweed
with my fellow poet callie gardner
and my old friend lorna hepburn
21 september 2019]

in this instance of a pace an at once
at one with its soon to be subjectile
what these footsteps in ash in ink will
have meant once a woman has walked
here will depend on how a woman
will have been defined by this step

down from the replacement bus
arriving in berwick-upon-tweed
september twenty-first first fruits
of this fruitmarket shift if i-i am to
be my beloved's my beloved mine
let it be unforgiven golden bovine

hoof lifted as if to enter an archive
of its own commencement its own
commandment as if a woman ever
enters an archive but here we stand
lorna and i-i want to say me but this
will of course depend on how i-i

will have been defined by this step
we walk the wall widdershins hidden
guns in plain sight unfenced sheer drops
beyond this point where the sea currently
called north admits the tweed it's my birth
river i-i tell lorna who lives in queensland

now but will she always be from port
seton lorna is game enough to chum
me anywhere i-i like to think since we
were first freshers in what has become
filed in my parlance under the unverse of
grubnide where no flocks were battened

but we both loved langston hughes
marge piercy dario's pizza red wine fought
the poll tax together before she left i-i once
heaved after lorna's disappearing sleek
heels as she sped up the radical walk
she is a triathletic triple black belted

karateist and rock climber she has
a level way of looking callie joins us
for scones we three entering the cinema
to see holly argent do battle with the archontic
paternal phantom of record of what is kwiekulik
armed with live feed self-projecting overhead

projector digital film and cones kwiekulik is
avant-garde polish for form is a fact of society
for action not work for filling the supermarket
trolley with products then carefully returning
each one to the shelf or refrigerator unbought
for paying hard cash in the gallery in lieu

of an exhibition which is the exhibition
for candles and chrysanthemums acting
breezy among the headstones for a lump
beneath the breast as the actual mark
of socialism's suicide and now holly argent
outlines the cones and troubled triangles

invisible kinships showing around the subject
that is zofia kulik [home▲work▲politics or
house-wife▲artist▲mother or kwiekulik▲
archive▲solo-work (and love triangles too)]
dividing her labour public and private holly
argent has tied a ribbon around her own

throat lorna has nodded off i-i am writing
on my phone the glassine triangulates
the candles and chrysanthemums are acting
breezy callie is busy with pen and notebook
as if each of all three of us already know we
are both image and speaker footprint and foot

lunch in the delicatessen is most welcome
and there are vegan and vegetarian options
(i-i fall for smoked haddock omelette with coleslaw
then cake) callie and lorna and i-i eat upstairs in sun
shine then we walk the wall widdershins hidden
guns in plain sight unfenced sheer drops

beyond this point where the sea that is currently
called north admits the tweed it's my birth
river west of here i-i tell lorna and callie south
is my fresh as if issued to children on a beach
beach where in the sand there were crocked
concrete blocks rusting barbed wire defences

prammed by an artist-mother or toddling across
the decayed decoy air-field to fool the luftwaffe
to paddle in cuppy sand in all innocence of boulmer's
type eighty-four surveillance radar able to penetrate
the latest soviet jamming technology we larked
we plunged we cheered at the old spitfire always

on the watch watchful for the tide coming in
once we were almost stranded but scrambled
up the cliff there were racing pigeons housed
on the old faux air-strip in winter the sand whipped
our bare legs in summer it was all we wore
our bed-time stories were all told in sand of

refuge adventure love and open hospitality to
all who knock on the door of an east-facing
sandcastle in berwick there's no time for beach
but we find a frost-bitten marble memorial
(group of seated female with two dogs in
charming composition in public garden over

looking the river) to the dead wife of
an ex-governor of trinidad and tobago
almost persuaded off her plinth by ear-
torn tail-docked unnamed companions
earthwards over tennyson's morbidity yet
in these ears till hearing dies one slow

bell one at her hand about to leap parsing
the passing of the sweetest soul that ever
looked with human eyes for a new early
listening device the other at her ear as if to say
undeniable everlasting contradictory things
bitten by frost into grey granite and white

marble these dogs i-i want to say are loose canine
morphologies acting breezy they are looking
for action not more work when i-i get home
i-i make dinner for a cousin i-i meet for the third
time ever who gives me a photograph i-i'd never
seen my jet haired mother aged sixteen in trousers

she is in a garden laughing away the war is behind her
arms akimbo she is striding wide-eyed into the camera

IT FEELS LIKE A WAY TO LOVE
for *Farah Saleh: What My Body Can/t Remember*,
22 February 2019

she has taken me by storm
a belly of collective moves

in daily artistic practice
her free advice solo knows

it is never solo she moves
with street dialogue into

performative space carries
singular concerns of passers

by into collective body
movements she asks

what does the space
know she performs

storm movement
this ambulatory

instance of creation
this occupation

body this archive
sternum resistance

dancer this studio
shoulder you know

she lives here some
where in this city

ARCHURBACK
(1982, painted and chromium plated steel, 51.42 x 35.22 x 29 in.)

John Chamberlain: Recent Sculpture
27 June – 26 July 1987

imagine eau de nil
in bent metal somehow netted
by white lace spray painted
grey open worked lattice
over a thick fuzzy grid
of lush lush black over deep
crimson deep vermilion bent
metal close to bent metal all
of these tinctures hold themselves
snogged into a corner by this electric
turquoise arch into silver
seafoamed chrome arched
metal tresses poised all
of a quiver fixed they are fold
ing into a frenzy going in for
the kiss the air
crackles this
concatenation of chromium plated
steel salvaged fenders sprayed
wild with enamel
is alive in its choices
fit—form—colour
all folding hard
painted steel into multiple mutable
free open genders this
is orgasm bouquet this is
yes high voltage sex

ON GROWTH AND FORM
(FIBONACCIS FOR LOUISE DICK)

it's
the
growth of
the artist
the form of the work
says louise dick here she sits on
sweet radius vector of fruitmarket what then is its

pole
pole
pole of
fruitmarket
from which she spirals
all her certain velocity
all her certain velocity into terminal

growth
growth
growth of
this artist
the form of her work
the force of her work's spiralling
magnitude its direction in out of fruitmarket

in
and
out of
fruitmarket
from which she spirals
form from which all her work spirals
what is the fruitmarket form from which all her work spirals

form
from
ram form
battering
ram battering ram
battering ram is the first thing
louise dick looked at thinking this is unusual

it
must
it must
be modern
art it's modern art
it was nineteen seventy-five
louise dick fifteen years old looks at *battering ram*

by
her
teacher
her teacher
john kirkwood artist
john kirkwood artist teacher took
his art class from craigroyston school to the fruitmarket

this
school
this school
says louise
dick is in one of
europe's most deprived places
this teacher just imagine it took us from that place

to
look
to look
at modern
art *scottish sculpture*
'75 presented by
the richard demarco gallery louise dick

looked
looked
looked at
her teacher's
her own art teacher's
art work *battering ram* with its
debris on the wall *battering ram* huge machine

like
a
gun like
a huge gun
facing a wall like
it had splattered stuff like who knows
insulating stuff debris splattered all over it

to
be
told by
your teacher
let's all go into
the city centre and this is
my work can you imagine the impact the impact

not
just
on me
craigroyston
school made so many
artists brian gibb painter paul
duke photographer davie duke painter joyce

gunn
cairns
before
us *after*
images city
art centre in nineteen eighty-five
showcased craigroyston's finest stuff including louise dick's

we
two
in the
city we
two in the city
picture we two in the city
in the city art centre and facing the fruitmarket

just
as
louise
dick is back
from st martin's school
of art london sweet radius
vector of fruitmarket soon she spirals she spirals

who
taught
louise
dick at st
martin's in the time
of the allegory boys i-i ask
all that mythy and meaty new narrative painting

just
when
concept
art almost
killed off mark making
if john kirkwood had changed her life
absolutely who in london had changed her life

like
that
with such
an intense
impact who even
cared eileen cooper her tutor
spoke the language of figurative colourist paint

she
saw
too in
her own work
gillian ayres
spoke up for mark making for mark
making's sake for joyous expression gestural paint

but
art
college
is so much
more than tutelage
louise dick lived in hackney in patch
work housing a hot bed of talents hung out with bands

like
the
mekons
and the scars
and the slits she sang
with the fire-engines i-i saw
her live on *top of the pops* sweet joyous expression

then
she
was back
her certain
velocity once
more through the door of fruitmarket
this is the growth of this artist this the form of her work

this
form
this force
of her work's
very magnitude
its direction spirals in out
of fruitmarket now she is gallery assistant

now
she
assists
fruitmarket
artists in the time
of mark francis for four years she
worked on the shoulders of giants she says not kidding

first
show
paintings
by gilbert
and george followed by
helen chadwick gerhard richter
cindy sherman et al in *the mirror and the lamp*

the
two
best shows
says louise
dick for her the most
formative richard hamilton
and nancy spero but for every single show

it
was
her job
to unpack
the van pretty much
hands on install all the work then
public education can you imagine being taught

how
to
mix dust
and pigment
for anish kapoor
to scatter on the floor like pods
and seeds or how about smearing paint like excrement

on
walls
bobby
sands style
for *ulysses* by
richard hamilton using two
fingers he went to saughton jail to get the mattress

and
rug
nineteen
eighty-eight
bobby sands was dead
seven years his cell in long kesh
replicated in form to house his diptych portrait

smear
paint
smear paint
two fingers
marking excrement
like the megalithic spirals
of newgrange the gaelic convolutions of the book

of
kells
is what
the artist
said of *citizen*
joyous expression gestural
paint sweet radius vector of fruitmarket how soon

how
soon
do these
spirals grow
spirals forming from
spirals this the growth and the form
this is the growth of this artist this the form of her work

growth
and
form is
the title
of the ica
show made by richard hamilton
for the festival of britain nineteen fifty-one

on
growth
and form
by d'arcy
thompson natural
lyric scientist of beauty
in the mathematics of organic forms spirals

how
they
grow how
do they form
in nature they form
by pole and radius vector
in ratios of golden mean a fibonacci

form
of
process
mind blowing
says louise dick mind
blowing all the more she now lives
in the very house where d'arcy thomspon was born

just
how
crazy
is that jane
imagine telling
richard hamilton all these years
later i-i live in the house where d'arcy thomspon

was
born
crazy
louise dick
out of fruitmarket
spirals this the growth and the form
this is the growth of this artist this the form of her work

now
she's
left teaching
twenty-five
years of teaching art
she lives in the house of the man
who put curves into numbers and words sweet radius vector

of
fruit
market
louise dick
this teacher of art
she has taught in st augustine's
edinburgh broxburn academy deans community

high
school
living-
stone wester
hailes then west calder
high school and musselburgh every
day in the classroom for these twenty-five years louise dick

has
made
art with
her students
now she spirals new
joyous expression gestural
paint she makes art in the house where d'arcy thomspon

was
born
how these
spirals grow
spirals forming from
spirals this the growth this the form
this is the growth of this artist this the form of her work

we
talk
about
the drawings
of nancy spero
running women
printed figures reprinted in overlays dance scroll

notes
in
time on
women sweet
radius vector
of fruitmarket now louise
dick is mark making joyous expression gestural

paint
this
artist
spirals she
spirals in all her
certain velocity louise
dick paints in questions asks of bleak areas where dreams

are
made
how change
is made she
asks in gestural
lyrical live mark making paint
where do we get this idea that something can change

things
can
change be
different sweet
radius vector
of fruitmarket louise dick grows
she spirals new work she will call it *on growth and form*

**THE MANIFESTATIONS OF THE OBSESSIONS AND FANTASIES
OF BRUCE LACEY AND JILL BRUCE IS A SOLO EXHIBITION
BY BRUCE LACEY**

(FRUITMARKET EXHIBITION 17 MAY – 14 JUNE 1975)

(FRUITMARKET EXHIBITIONS AUGUST 1974 – JUNE 1987)

his manifestations are not hers we gather she is his
in this show the summer of nineteen seventy-five may
brings magic into the land and june is turning bright
and strange and almost all in the course of one lunation
a may moon a flower moon a milk moon it manifests
this the fourth of the first ever fruitmarket shows
she is his substrate we gather his maddening subjectile
thrown throwing she is nothing but a solidified interval
visible and invisible before and behind between lying down
and throwing she is force before form the subjectile is a figure
of the other towards which we should give up projecting anything
is she his substrate is she his subjectile she is not even his exhibit

installed on a lower left molar
he speaks through a vast mouth darkly
a painter a pacifist a tightrope walking
knife thrower an actor producer magician
an explosive maker a turner of ritual
the manifestations of the obsessions
and fantasies of bruce lacey
and jill bruce takes the form
of a journey through his life
in assemblages props
and contraptions
the exhibits range we gather
from his first ever toys—models
of 'red indians'—to his latest films
and sets such as this vast mouth
from journey through the organs
of the human body in which he sits
through which he speaks to the times
his other films include how to have a bath (with
jill bruce his wife) and the lacey rituals (in which he co-
stars with jill bruce kevin lacey tiffany lacey saffron lacey and fred lacey)
he has married twice the second time to
jill bruce (née jill smith) with
one of his robots as best man
in our society adults play
he says with their children very rarely
at bank holidays but with my family
our work and our play are one and the same thing
children are what people are meant to be
we believe that what people do
for their hobbies
is what they should be doing
for a living
living out this

theory lacey and his
young family take his
multi-media
ex-army tent
to festivals
other places
where children
can be found
to play around
with climbing
with painting
messing about
do not mistake
these words
i-i spurt here
and spread
for the show
these words
merely a dip
and a tilt
at its nin
crot and
pulley

is lacey's the first solo fruitmarket show (how is any show a solo)
first came 11da: eleven dutch artists shone on from new corn moon
to new harvest moon and a little later under the waxing crow moon
came a choice selection (the archive lists two scottish artists one
chooser one chosen) then scottish sculpture '75 (by eleven
scottish sculptors) arose under a new pink moon no you do not
need to be told that they are men that all of the twenty fruit
market artists so far are men or that bruce lacey is first fruit
soloist (jill bruce his wife being not even his exhibit is so not his coll-
aborator) thus making the twenty-second fruitmarket artist (no not
jill bruce who is after all not even an exhibit but a name in the list of his
works for example under nineteen sixty-seven wedding event with robot)
but allen jones picture midsummer stilettoed waxy legs astride a low hot
moon a strawberry moon or is iain patterson perhaps the twenty-second solo
fruit he too under a hot strawberry moon the four scottish realists all buck
moon and new antlers that follow take the tally to twenty-seven but
who the catullus is counting up there the last apollo eclipses the sun
so soyuz can snap her corona and then we come to the 8 from berlin
a barley moon a fruit moon a sturgeon moon can you smell the fish not

not yet it's between a waning harvest moon and waxing hunter
aspects '75: contemporary yugoslav art is a comprehensive show
of yugoslav artists (the archive lists four but there were forty-nine)
including performance work by marina abramović a terrifying experiment
on her own body called hot/cold she held her hand on a sheet of glass under
a block of ice with an electric fire suspended above it for half an hour then she
uttered a cry and smashed the glass cutting her hand but she remained in position
without moving while the skin on her hand began to burn until the audience called
for the fire to be switched off yes marina abramović is all the archive sees now (see
the fruitmarket archive see the richard demarco archive) no you do not need to be told
marina abramović in twenty twenty-one but do you need to be told ida biard yes ida biard
between waning harvest and waxing hunter what did ida biard bring to fruitmarket what did
ida biard perform how did ida biard assist ida biard is the founder of la galerie des locataires
in a rented apartment in paris in nineteen seventy-two (the gallery of tenants) she declares
the artist is anyone whom others give the opportunity to be an artist asks artists everywhere
to mail their works for exhibition in her apartment or for realization according to instruction
in other places until nineteen seventy-six when she went on strike the protest of a curator
a curator against the conduct of artists she is against the conduct of the so-called dissenters of
the so-called avant-garde within the current system of the art market but the fruitmarket
show came before her strike the fruitmarket show was between waning harvest and waxing
hunter the fruitmarket declaring with ida biard what ida biard declares to artists everywhere
the artist is anyone whom others give the opportunity to be an artist gallery as postal service
mark boyle's journey to the surface of the earth saw in the winter solstice of seventy-five it
was ten more years before his collaborative work with joan hills and their children sebastian
and georgia was shown under the collective name of the boyle family meanwhile jill bruce
has become jill smith leaves the lacey family for a ritual journey around a sacred landscape

no you do not need an airtable grid view to tell you it took five years five
years and fifty-one fruit shows until eye to eye: video installations a solo
show by tamara krikorian featuring vanitas (or an illusion of reality)
vanitas (or an illusion of reality) is the third in her vanitas series
vanitas (or an illusion of reality) consists of two channels still life
and self portrait there are two versions of self portrait version one
was made in nineteen seventy-eight in black and white version two
was made in nineteen seventy-nine in colour was it version two
in the fruitmarket the debut work tableau places a live broadcasting tee
vee another tee vee turned towards a large wall mirror reflecting the image
of the artist in a one hour take both installations make use not only of video
and mirrors but actual still life objects flowers and fruit wilting and rotting
the artist fading again and again in the broadcast space as they wilt and rot
krikorian is placing tee vee among the bubbles and other tropes of trans-
ience in historical vanitas painting both installations were in a specially
constructed space within the gallery and in the outer space was a separate
section of documentation—dye-line prints with quotations from the note
book for the project photographs of cartoons about television an interview
and documentation about previous work—i-i have watched courtesy of lux
the vanitas video of nineteen seventy-seven the artist is before the mirror
reflecting a still life with fruits a candle aflicker an opened wine bottle a tee vee
richard baker is reading news of the historic ceremony marking spain's trans-
ition from dictatorship to democracy cut in on by the fading artist mise en abyme
recounting her encounter with a painting in oxford probably by nicolas tournier
an allegory of justice and vanity which has haunted her ever since hence her
own vanitas hence this vanitas (or an illusion of reality) installing fruit in the fruit
market flowers and fruit wilt and rot the artist fades on a loop autumn nineteen
seventy-nine the hunter's moon waxes then wanes now the beaver moon rises

(do not hold your breath)

a simultaneity of women through time is
 how nancy spero describes her running
 figures caryatids on the lam a scrolling

 artemis is sprinting alongside a modern
 athlete a prehistoric shadow figure is
 dancing behind them a goddess she is

 a powerful self-sustaining and autonomous being
 capable of moving through life as freely as a man
 lightly between bedroll and baby a bag in each hand

she is between
above and below
visible and invisible
before and behind
this side and that

is how i-i see her moving
she has taken to walking
thrown and throwing she
has thrown off
an environment
has thrown off
herself as an
environment of
the others

i-i am spurting and i-i am spreading these words i-i
have been reading and mixing these words they have
something of the subjectile the substrate something
not speaking of and not speaking for something i-i am not
wanting to make a figure of the other i-i am wanting
to be thrown throwing by the subjectile the substrate to
surrender lying down and throwing i-i want to surrender

she never cared for this maze a chronological pathway
her least favourite show in a labyrinth form
less memorable than the broken bonnet hitting the windscreen of the hired car

ginger to his fred in the electric element she wrote the catalogue unacknowledged
backstage she was hearing her ideas voiced out front with no credit

 she performed a robot striptease down to the bones
 she was proud to be taken at alternative miss world for a gay man
 she performed the rainbow at the albion rainbow fair
 she performed the moon at the albion moon fair

written out of the retrospective like a possession now lost
all the costumes and the props she designed and made on display unacknowledged
most of her images without credit

she prefers sunlight moonlight oil lamp and candles
the moon moving her body in watery dark depths

in the green throat of the land
little rustles of small animals
a little heather hollow
a nest in the sun
yellow irises and no trees
eagles nesting on the nose
of the sleeping beauty
her brow on her brow
where all the journeys meet
sisters in fire and water sisters

he had stolen her language
her self was torn from her self

she has slept on her knees
shins to the ground
deep in the chambers
of neolithic long barrows
old mother chambered cairn
old mother long barrow
all her fragmenting atoms hanging on exhausted by vision
eyes open felt shut
eyes shut felt open
she has distilled her wild writings into a few clear pure lines

at the common embracing the base she sang the song of the mountain
becoming boundless at the fence
for her the mountain is the sleeping beauty

she has seen the old hag dying becoming maiden
walked in spirals on a dreaming path
followed the map in shape of the divine hag
slept among the rattling leaves of yellow irises
paused by the well of the dead
walked on hot streets
slept in the ditch of the world

she knows we cannot fill mountains with death
she knows when bowie comes on the jukebox it is time to leave
she knows the soft shape of the place the furriness of the grass

moss is growing on the pillars of war
she finds a quiet place by the fence
a green helicopter hovers over the washing nappies

peace walking to greenham pregnant
she becomes spiderwoman
soon on the other side of the world
she is cooried in at the side of uluru
with the baby and a saucepan of quandong

she has seen the crone beneath the maze
querying the need for words
shifting realities under the yew
crossing tower bridge by horse and waggon
she finds two realities crashing head on

she senses patriarchy in the stones of stonehenge
she knows to leave the green ant in the earth
she loves the peat reek
she has moved with the turn of the planets across the unbounded land
she has strung a crystal on a red thread winding out from the common
 into winds that blow wet with serpents all around her head

she knows the when and she knows the where of how to wait

for the low june moon to stand still
on the mountain
she has seen the earth give birth to the moon

a woman alone by choice

a wilful wanderer

Iain Morrison

Previous page: Kate Livingstone, *Since Venice*, 2021
Ink and acrylic on paper, 42 x 60 cm
Title taken from Iain Morrison's poem 'Ballad of the Creative Europe Desk UK in Time of Travail'

Tom tour has me thinking about surfaces
 and
 after a smile
 here I am writing this
down out of Tom's slipway, so as to respect his
 what-may-be-seen,
using the opportunity.
thinking about Virginia and the mothers in here
eating us across, but we don't have to be modern:
are moderner all the time

 we're accepting money, and *then* conditions.

Accounts, for bold fringe, larger space
 standing up, pushing out incline towards
 those who would benefit from feminising
 better to take photos. With permission,
 we're here to save a day in Broxtober

 for weather is fundening. Pegs cataractual
 whose were, somebody else's.
How the centage of their skin
Doric, mnemonic lost for remembling their building.
And that's a space, fails a flame
it may be inextinguishable from. Our guest could be more gustworthy.

They are supported by at least seven floor
 builders hard above us.
or it is a party ball, glittery showy core, a snowy shower, a showy shower?
 Generation is my game,

successive, resistual
 spans spreading feist on trust.
 These were circular marks read
in comfort for each other. May be expensive-est words
 ever did wrote growing still tracking
 through wings, water and apps.

One Day Without Us meeting
27 January 2017

Bloody Foreigners campaign.
part of the National Dialogue
whatever your small action is.

100 businesses to support the day,
(poet) getting an Edinburgh ODWU Twibbon
[message to MSPs is happening]

First Minister's Office are interested in what we're doing
 - SCOTLAND WELCOMES THE WORLD
Serenity Café as a possible celebration venue.

Una knows migrant musicians
Oona can do Meadows Festival
Hemma celebration afterwards.

IM to ask MILK about cake/table
2 tables for this.
Cake is low risk, just don't do butter icing.

Getting migrant voices heard
SHOW RACISM THE RED CARD
Message to or from a migrant – therapeutic function

Alien Smith organised 2 Brexit events.
also National Women's Strike 8th March
MUIRHOUSE ANTI-RACIST CAMPAIGN

1.30–7pm @ the Mound, withdrawal of labour.
precariarisation makes it impossible to strike
 - MIGRANT STRIKE EVENT IN LONDON (10th Feb)
MIGRANT STRIKE IN ITALY, 2010 Banners question

Aftermath

Spirited Voices: Edinburgh International Festival, 9 August 2017 #spiritof47.
Allan Little (chair), Maya Zbib, Willie Doherty, Esa Aldegheri, Harriet Lamb.

> *The problem with forgetting*
> *The problem with remembering*

from 'Some Notes on Problems and Possibilities',
Willie Doherty: Buried, The Fruitmarket Gallery, Edinburgh, 2009

They've done the role of arts in other conflict
 In Lebanon the conflict always is present
political not propaganda not said
 not dealt with. History a concentrating face
pallid, clammy multiple down below
 a fire is gloaring out in post-colonial
context. Narrative steps out of their own
 narrative. Don't put children in a situation
where you can't deal to group with the wound. Culture

metaphors in fairy tales for example
 hold violence in them, knivings that she wanted
to tell in that moment. Cannes, Aix-en-
 Provence, a way for Europeans have eyes on
each other, to the convex of North of Ireland
 the face turns. I prepared something
I thought. I might read it. Why avoidance
 the drama of voiding the human figure.
A parallel activity to the broadcast media ban.

Someone who lived proscribed in organisation
 limits of ban consequent the voices of actors
my use of voiceover voiced by the same actor
 will be shot, will kill somebody else.
Murderer and victim share the self-same impulse
 reading or being stopped in the centre or sanctum
this level of attention and diplomacy
 and I really face cut out for this
there still will be good things we act like we've forgotten,

I have seen them serve the Europeans
 who've forgotten conflict to remind them,
there is need. There is just surviving.
 Waiting for Godot sieged in Sarajevo.
People risked their lives just to see it
 Sontag brought us something UN couldn't
that was need, a lesson. Harriet let me
 ask, a sponsor, when you have in mind,
a very brilliant work some seventy years ago

the guns fall silent. Thank you. To give voice,
 the mics drop out. Peace-building. Biggest battle
death and North Korea ratcheting up
 the citizens can come, can live together
again the people who've been brutalised
 unless we invest in their humanity
because, let's face it, it is usually men
 Tunisia's maybe lucky what he'd know
through most his life he'll lived through conflict, can the end

be as traumatic? Then the pressing ahead:
 it's right we come, we came and nothing happened.
Because there is no justice, not just him
 the history stops because noone agrees.
Everybody knows where the mass graves are
 but noone's will is opening them up
To open one grave up and not the other?
 Imperative forget. Hard to accept.
A Christian undertaking, this is your circumstance.

The face, the hairs, this what is there, what do you
 mean peace? We started out from in history,
we didn't think about the key thank goodness,
 symbol-saw seen in Amsterdam eth-museum
same though different symbol ethery where
 I have killed people. People know militia
a year then they don't know how to tackle
 dividend exhausted cohesion are exhausted
images are exhausted come to in a process

to indulge there's only so much setting
 aside that is sustainable the words
are exhausted, politicians and political class

very little prospect in this society,
society underestimates the arts.
 The other side of aspiration that
the arts can contribute, it's valuable work
 it's not about the arts providing succour
but what else can they do? The language digging includes

the funders, and where do you go from there?
 Curators of the national gallery bought one work
but it stayed valuable sole for its own sake.
 Behind me in this bit I found annoying
he's killed ten members of her family.
 In a way he has no choice, distinct behaviour.
Per cent of population are refugees.
 The Lebanese left because they're angry, alert.
No wonder 'the Lebanese' weren't welcoming she smiles

after Syrian occupation none of which
 in 1947 then the national
health service was set up, in turn
 a narrative of scarcity, or a society
where people seek refuge, cards, whatever allows
 the imagination of the resentful person
to admit the person to their own narratory.
 Lots of different mediums of shying away from
conflicts, reapplied. Perspectively demurring.

For three and a half hours' flight you're in Ukraine
 This is ridiculous that we're at war
Millions of internally displaced places.
 People can art be a force for bad?
Murals put me in mind of the North of Ireland.
 Adopt language with the consent of community,
hedging their bets until they can find replace
 something is more aggressive, harder to speak.
The art stops the art, the beak stops the beat.

The only way the art could be of use
 is if it has effect on the way of government
on government itself in a mural amnesia.
 No one would take the trouble to hold condition
for the bad reasons. At moment there's source of funding
 affecting narrative quality of the war work

because it's political (all money's political)
 but you have to navigate through what each fund comes with:
agenda. 'Do you have something about war?' he's a good guy

but the question drives me crazy, we always question
 our intentions, you have to know you're not helping
an expression that might otherwise not be happening.
 Undoubtedly Nazis used art (always on both sides),
are we instrumentalising art any better for peace
 than for war, unless it's negotiated?
Vienna Philharmonic played in the building
 that inly unveiled a statue of the assassin.
Sharing the same compartment gesture conciliation.

We try to stay away from the government.
 To not be known by the government. Because
we want to be able to go on doing our work.
 We don't believe the people in the government
are working for the people. Aggress him directly.
 Rel, our work is effect with sex, religion
politics, preach to the choir, specific examples:
 in a country where gay men were put in jail
there's very little hope, members of the company were leading

untenably risked demonstrations, the post conflict
 is very, very long sustainability
where is there peace? Here? Peace is much more than
 absence of war. Am scarring the pre-conflict easiness.
The conflict departs whatever that means,
 that work, maybe I'm ready, *Ghost Story* remains
at The Fruitmarket Gallery provisions, police and control
 an inheritance from the same family,
places exist, another phase, borders of words.

I would if I felt that having some shape in the language
 actually opportune meet two of the government
(scratchedly didn't go anywhere, not very deep).
 It's my, to take serious comfort people might seeking
complacent, complicit, willing to share in order,
 sober around us doesn't allow to step
the street is responsibility, information
 everyone murmurs completion pronunciation
you ask of a piece of art extractive allows a single.

This is two things: lives that never listen,
 Milan completely destroyed, the whole thing stated
through motto, Bojo, no-notto not finding an ending.
 Minefield on stage this evening Malvinas veterans
I'm drawn to, I'm drawn into that one, then Martin
 Creed with his table. Can someone develop without
imposing, this mode? The power of art the choices
 not given resources to storyline through, to pose
yourself at people bracing their sames for grand criticism.

Times I've scared because of the art at work

The dubious natures of smelt seawater packages sent from round the world
to a shelf near my desk in their envelopes, stained, successful,
awaiting transfer into Tania Kovats' *All the Seas*. Would they
release into the air some sort of aquatic parasite?

Horror at anything ick in the files Dieter Roth brought:
posthumous, exhumous, humus. But most, that box Antonio
Manuel sent: 'Urna Quente (Hot Ballot Box)', but urna? He was
in it. Heavy lump-rocked and locked, I convinced of irradiated,
cured flesh, slowly killed me through the office wall

revenge, and then when I placed somehow in
charge of the mics for Susan Hiller's talk. That moment
of panic automatic, she started to speak and I slid
the fader up in time with eyes held to Fiona's.

For Gabe Passarelli, when in her hands she chose
to burn many incenses, isolating the right detectors
hoping I'd gauged spread for safety, the cinder scorches
the floor. Afterwards, waiting in case a slow burn
had started. Poured water for ages to take
heat out, feeling wholly responsible. Gabe's smile,
she said 'It isn't a white cube any more.'

2 workshop poems

i) from Janette Ayachi's workshop

House of Books
Books housing
 that thing
that comes up
about a space being enclosed
or whatever the opposite of enclosed is
Enopened?
 Closed in order to be re-
Opened again. The books support
 the literacy/fluency/agency
not read though/read-through at that point
or maybe bilded into a strengthening.

ii) from Callie Gardner's workshop

Kingstable Road Gate
Sterile Areas WPSG
Kingstable, like Dunstable.
OPronounce it that way
With type-O typo.

Lineate in a table
ALL STAFF WILL ASSIST
WPSG wiping? Trying to
parse grasp what that
WPSG must B. Unsureclear

WITH THE SWEEP of
With SWEEPING
WEPSING, weep
sing in the GARDENS
as IF REQUIRED.

Ballad of the Creative Europe Desk UK in time of travail

My love, I enclose you some words from abroad,
 for abroad we assuredly must be.
Though I saw you last year and we joked of our fears,
so much since has happened it's signally clear
that now at the present, epistolary cheer
 is all I can offer to you, my love,
 for abroad and at home are we,
 either one or the other, you see.

Tonight as I write this, I travel in thought
to only last August, that invite we got
 to meet and carouse with the Fringe-brought throng
 in the refurbed suites of Cecilia's Hall;
 how light and how distant that scene.
 Yet still at the time we'd attuned to the clime
 as it shifted from kindness to something less than kind.

These notes that I cribbed on my handout that night
I can comfortably read in the late solstice light
 so close to our northern sea,
 and sending them now I intend they be tokens
 taken to speak of my faith and devotion
 till we may reciprocally solace again,
 together in person as well as in pen.

Creative Europe Desk UK,
 panel of working nets,
eighteen million euros a year
 for the UK's cultural bets;

much like an anti-Brexit rally,
 reassuring to find,
with means to support the sector's ideas
 at the site where they spring to mind.

The sole illumination response
 not powered alone by wind,
this grid will run on disregards
 even if lights are dimmed
 And even if lights go out, my dear
 the chance of an end is slim.

We're asked to proffer a challenging word,
 I give up the verb 'to bide'
and usually don't use actual names
 in case they're identified.

There's talk about how not to capture
 people on behalf of the state.
 And the surveys run by the ICM,
 measuring change since 2010,
 chart the rising of hurdles and gates.

Pushplay's artists hail from Wales,
 Ana and Gareth are twinned.
Claudia Zieske's part of it,
 newbies still opt themselves in.

Europe Dance House Network now
 my sisters come up on screen.
These were those supported to move,
 now where in the bloc have they been?
 Yes where in the bloc have we been, my bun,
 with our passports so pleasant and green?

Jean Cameron speaks from her Paisley role
 as host of proceedings today;
the panel applaud, they fan their support
 on our Scottish pretensions to stay.

I haven't seen Jean since Venice that June
when art had all of us flood the lagoon
 and the streets floated up to my knees.
 But the time for regret it has flown with the bees
from our borderless, beckoning blooms.

Yet something of Italy summons back
 a dormant irritation
 from my posture in real or virtual calls
where getting an Irish woman to speak
 for only two short minutes at all's
 a challenge beyond a nation.
 But by what other means might her insight's stream
 well into our organisations?

Trans-national meetings. Will homelands retreat?
Their frontiers between us be bristled and neat,
our open-source knowledge base branded elite
 in the push to remap our allegiance?
The affirmative answer, sadly it seems;
nor can our careers, let alone hopes and fears
 forestall the Brexit scheme, my love,
can they parry those Brexity memes.

Greta Thunberg's wave-washed face
 keeps looping round in the slides;
 the cartoon sea's beneath her nose,
 through which she's breathing I suppose
 while her mouth submersed in the tide below
 shows lips resolutely steeled.

This speech rings modern, a Western vibe
 of key change demos from Sweden,
where seventy-five per cent of men
 are sloshing around in music:

'They can't play drums, they do nothing,
 while womenish/non-binary...'

 we witnessed the speaker's faltering grace
 briefly draw the blood from her face
 while she caught herself spinning, as when in skips
 of turbulent thermals an aircraft dips
 then rises to safely fly on, my dear,
 resumes with nothing awrong.

'...fifty-fifty within five years,
 you know what I mean, you know what I mean.
Well I spoke to her two hours ago,
 I told her she has the gig.'

We're skirting around ideas of care
 enough to impel some action,
will come back to our pledges afterwards
 with statistics added for traction

whose gears are keenly felt for here
 while the passenger dread sits heavy on us
 as it rode once Sandra Bullock's bus,
 while the waves at Greta Thunberg's chin

circle round on the slides with incessant routine
keeping us islanded in, my fiere,
 keeping us deadlocked in.

We're getting a boat to Gothenburg,
traversing by yacht to Gothenburg,
 Greening, we were behind.
 We have to squarely face the fact
 while hoisting our artists up to scratch,
 to surface from underground.

State enablers, you'll win work,
 Portugal is now.
Onboard national audience first,
 play the union down.

Because I was mostly thinking of race,
 just noticed the panel are women.
Had hoped to find representation in place,
an assembly of standpoints making this case
 from experienced, honest opinion.
 But remember who were our hosts that night,
 the Creative Europe Desk gets much right,
 and gladly I saw that it was,
 yes gladly I saw that it was.

Though wit those cliffs ne'er gleamed so white
as they glare this eve of Brexit night
 while the Europe desk spreads its wings out wide
 to be pitched and dropped by the narrowing rides
 of a strangely deflating breeze, my liege,
 an expiring, puffless wheeze.
 And skiffs are loosed about the bay,
 that darned transition's underway.

'O pluralist Europe, helm hard from the right
wheel our fancy with all your might!'
 In my vision, Dover is lost to sight,
 a fair wind blows us through German Bight
 while we hymn in praise of the panelled day
 and hearken further to what they'll say.

Mia Ternström from Musikcentrum
 Öst, World Axis Ballymena's

Emma Connors, Dawn Walton
 from State Black Arts, the room

now minded of the matriarch,
 hears report about *Ouse Woman*,
 Ilona's project that triggered a switch
 in the play of our gendered relationships,
 performed on site at Crinan.

A monotonous man had pushed himself in
 ever looking to use
the woman or opportunity
 as medium to platform his views

we had to stand to listen to
 his scolding then in a river
Self-important loud halloos
 to conceal he'd been taker not giver,
 yes very much taker not giver.

Being her friends, we told her to seek
 juridical redress,
accepting that structures of legal aid
 were hard now to access at best.

But in looking to prove her ideas are hers
 the woman falls down on her luck,
Ilona encountered misogynist slurs,
 she was doubly financially struck.
 Such is the bias we seek to replace
 in paternalist regulatory space.

The unresourced body through Europe as well
 is frequently criminalised.
By any ruse we can we'll help
 our artists professionalize;

credentials will need to be boosted for when
 Schengen observance is frozen
while crossing borders, taking their trade
they'll often be sabotaged, likely waylaid
 in each of the cities they've chosen.

The clock will attest, we've gone over our time,
　you're witness to magic that happened.
Pray hope our charm irrevocably's left
　underneath the political pattern.

My notes attain their ending there,
　was there more of catharsis than hope?
Perhaps there were traces of words to the wise,
　clues that will help us cope.
　　Yes I think there were glimmers that further assist
　　in our plans to regroup and our work to resist.

So steadfast friend haste share your posts
　we must continue strong.
The censoring eyes rest yet half-closed,
　the internet's still switched on.

Wherever we go, whomever we bore
(I'll admit I'm unsure what that panel was for)
　do let us stay fond as the memories we keep
　　though the Creative Europe Desk fall obsolete,
　　　for never wavers the creative breast
　　　and your Scotland sends their creative best,
　　　　adieu, my love, adieu.

Things the reviews said about:
Jean Michel Basquiat: Paintings and *John Cage: Prints, Drawings and Books*,
11 August – 23 September 1984

Jean-Michel Basquiat

roughie toughie darling
street-wise street-smart artist
painted scrawls have undeniable power
untutored rawness layered over with urban sophistication.
refined and sanitised savagery

Jean-Michel Basquiat

scrawled
24-year-old artist
throws critical clichés back in their faces
an elaborate collage of cut up colour-xeroxed drawings –
a sort of automatic sketch technique by which he transfers his small drawings
directly to a larger work
with
colour, lots of it, brilliantly used

Jean-Michel Basquiat

some gloomy Victorian poet unaware that he is sprouting dreadlocks
darling of the establishment

Jean-Michel Basquiat

childlike scribbles
24 year old
black ghetto kid
wild, drug-induced graffiti antics
his ego has been massaged
superstar image
sees himself as the young king of the art world

Jean-Michel Basquiat

physical energy
impoverished vision

Jean-Michel Basquiat

commercial hypocrisy
"Self-Portrait as a Heel," one of the oils on show, is perhaps nearer the mark.

a snake straight out of the Disney Jungle Book hisses across the feet of a black
man

badly written art historical/French impressionist references in his
ugly acrylics
Did his dealer [come up with that]

poor soul
it would appear [he] suffers from dyslexia among his other afflictions

crude messages
mask-like heads

rough-and-ready
semi-slap-dash
semi-slick

deliberate painterly panache
quasi-academia spiced with streetwise outrage

Jean-Michel Basquiat

He is 24
he has brought a certain gravity to graffiti.
scrawled over with obscure, angry messages
tribal war games of the New York subways
funnier and less pretentious than that sounds

Jean-Michel Basquiat

one of the few young American painters to have made his mark in recent years
is only 24

We'll see

John Cage

touchingly emotive conjurer
allusive, delicate imagery
gossamer web of the emotions
opulence in minimal form
a delight

John Cage

a quiet 72-year-old with a birdlike face and a childlike smile
spidery graphics

John Cage

sophisticated doodles
sophisticated scribble
so minimal as to be almost invisible
one photo-etching […] is actually rather beautiful, but the rest merit little
attention.
would […] be overlooked at any art school degree show
so old-fashioned that it is a kindness to pass them by

John Cage

far cleverer
a master

some of which are extremely beautiful
some, frankly, empty in every sense

John Cage

John Cage

the composer who composes silences
'he is best known as one of the foremost composers of the twentieth century'

News to me

here as a printmaker and draughtsman,
the processes are subject to the same chance procedures as Cage's music has
been for over 40 years

We do live and learn

SOURCES: contemporary reviews from: *The Sunday Times, The Scotsman, The Observer, Glasgow Herald* and *The Guardian*.

Tom
Pow

Previous page: Kate Livingstone, *Pursuit*, 2021
Ink and acrylic on paper, 42 x 60 cm
Title taken from Tom Pow's poem 'The Fruit Market – Extension'

CONVERSATION

Hello, I am an art gallery,
an impressive structure
I think you'll agree.

Oh hello, I am a poem.
I am also a structure.
Without a structure,
I too would fall down.

I am an art gallery.
I am constantly changing.
When you walk into me,
you do not know what you might find.

Indeed. I am a poem.
I am set in my ways.

But when you walk into me,
my hope is also that you do not know
what fresh discoveries you might make.
I am a forest with hidden trails.

And I, a gallery, am a country always
with new thresholds you can cross.

I ask of you nothing
but that you cross these with me
and are open to whatever
landscapes you may find.

Indeed. But I am a poem.
You can slip me into your pocket
and take me anywhere you choose –
over any number of borders.

That is my gift, though I must
change my plumage as I go.

I know what you're getting at,
but I am an art gallery. I stand

where I stand: whatever plumage
I wear, I must wear it here.

The idea of me, on the other hand,
will survive beyond these walls
(beyond any walls that try to contain it) –
as will the idea of you.

Further to that, no one
need show favour to either of us.

THE FRUIT MARKET – EXTENSION

Where we can still breathe, unmasked,
space has innocence, anonymity.
We cup it and let it go
like a fly we've failed to capture.

We trap it best by building around it,
turning space into place
 as here –
though any enclosure
carries history, its own
or one memory or imagination
may give it. This building
is hollowed out like the hold of a ship,
absence broods in its corners. Yet
enough colour –
even an Electric Orange! –
still gestures within it to recall
a vibrant joy, a place
where hearts once beat in the pursuit
of soft fruits. And beyond that,
there is the scent, dreamed on the air,
of orchard and of earth
and the calls of commerce.

Nor is it hard to imagine
a sacred place, a dusty
but respectable history. A lozenge
of light, hesitant, new born
(one of those Le Corbusier conjured
at Ronchamp), flickers from one wall.
Think of an altar candle, struggling to catch –
till confident, forthright and steady,
it illuminates corners you thought
light had rarely cared
to reach.

PORTRAIT IN LIGHT

'here I am writing this
down out of Tom's way so as to respect his'
 from *Untitled* by Iain Morrison

For all that, there I am hiding
in your poem – the hesitancy
behind the bluster, the receded
hairline, the fleshy nose. Now
you call from me a similar respect
as we knit the cobbled limits
of the neighbourhood.

We belong to all countries!
The local is the universal minus the walls!

Your laughter is light and ready,
your face a lantern lit with joy. Is this
the way (please God) the world can be?
If so, you bring those who greet you
halfway there.
 In the gallery-to-be
I took a picture of you, notebook
in hand, unconsciously posed
before a panel of light. The sun
blesses your face, Rembrandt-ing it
(a patina of time brushing
your golden whiskers!). And,
as Rembrandt overlooks nothing,
there it also is: the concentration,
the seriousness that playfulness
demands. Before you –
 to paraphrase a poem
of Brecht's, lauding Charles Laughton –
the arc of your belly is performed
like a poem for your edification
and no one's discomfort.

I can send the picture
if you'd like.

MASONRY

'An image means nothing.
It is just a door leading
to the next door.'
　　Antoni Tàpies

1. Fruitmarket

Light came clod-hopping in
and split the darkness. Sometimes

you need a bit of that –
the wrong word in the right place.

If you can't draw something,
　　　　　　　　just draw it.

Once, lost in a rainforest,
I hugged a tree and called it *Mi madre.*

Now, I put my cheek against
a cool steel dependency. *Mi padre.*

Mi padre was a man, who knew
it was not simply the band of colour

that moved you, but the delicacy
with which, in space, it was placed.

When a landscape moves through you –
corncockle, cornflower, rocket

and mint – you can have the same
feeling: a bit like a door, opening.

2. Venice

Drawn to 'unfinished conversations
on the weight of absence'

you suck from your knuckles
the granular facts of a wall. Then –

you pray for the embrace of a harbour,
while treading the *acqua alta*

of the tide. All of this is ballast
you can use. Come evening, you re-take

your seat in a refectory of voices.
The world's joists are slotted back

into place: no argument there.
You take a knife to the spine of a fish

and ease out its backbone whole.
Its flesh divides into feathers. Out of

the corner of her eye, your daughter,
now grown, once saw angels in flight.

There, graffiti'd on the metal door that will lead into the 'new Fruitmarket', is the clear instruction, '**eat the rich**'. It is of modest size and all in lower case, nothing so brazen as an exclamation mark; perhaps making a secondary point: this is no shouted slogan, nothing to signal rebellion, revolution or affront. On the contrary, the writer seems to say, the three words are nothing more or less than a bit of good old Scots common sense. Moreover, their isolation on the door – no 'likes', but neither anything that says, '**And fuck you too!**' – suggests a level of respect, if not agreement, from those who chance to be passing, or from those newly arrived, for a Festive Break, in the Athens of the North.

Standing in the cold, waiting for a taxi, few will identify the imperative as having been filched from Jean-Jacques Rousseau: 'When the people shall have nothing more to eat, they will eat the rich.' Instead, they may consider it a policy from one of the minor political parties. ('Yes yes yes, let me be clear about this: at the moment, it's only an aspiration, we'll get to the practicalities later.') The rich themselves are confused. They always thought folk would start, if needs must, with students – or with the homeless, of whom there are several within easy reach, shelved up the steep closes.

Market Street
November 2019

THE GOOD BOOK
Market Street

He sits at the back entrance to the station, a good spot, as it's close to where the taxis are waiting. He's cross-legged on the nest of his blanket, behind the card-board message, which begins, I am not an alcoholic...and so on. The white polystyrene cup with some small coins in it sits in front of that. He's small, wiry, sharp-featured as a bird, with a froth of blonde hair. His face is dipped towards a thick book, a paperback, on his lap. He glances up from it with a Thank you when my coin hits the others. I take three steps away, then I retrace them. What are you reading? I ask. He holds up the book. Oh, Sara Paretsky, I say, I've heard she's great. Aye, he says, ah huvnae read her before, but ah thought ah'd gie this one a chance. Ah read a new book ivry day. It was mid-morning, only a few pages gone, but the cover, with its vibrant colours and its jagged forms, said, Page turner! said, Time passer! said, You are in the world of this book! I left him to read, to read and to beg, without taking careful note of the title. But I'm sure it was one among these:

>*Blacklist*
>*Breakdown*
>*Body Work*
>*Bitter Medicine*
>*Dead Lock*
>*Hard Time*
>*Hardball*
>*Brush Back*
>*Fire Sale*
>*Fallout*

Guardian Angel? No, I'd have remembered that.

EAT YOUR GREENS
EAT THE RICH
EAT YOUR GREENS
GREEN THE RICH

NEON 1

THE FRUITMARKET NEIGHBOURHOOD TOOLBOX
(towards a Culture of Encounter)

NB The words 'Neighbourhood' and 'Village' are a question of accent throughout.

'A neighbourhood is a state of mind'
 Peter Turchi (from *Maps of the Imagination*)

1. First steps. Tie yellow ribbons where you can around the boundaries of 'the village'. Invite people to follow them.
2. You are a tour guide. Lead people around 'the village' in a language that is not your own. You may invent one.
3. Design cards with the map of the village on one side. On the other side, ask, 'Which neighbourhood/village did you grow up in? Name it, describe it, outline its boundaries.' Distribute in each café. Invite customers to share their cards and conversations.
4. Celebrate Neighbourhood Day (whenever you decide it to be) or imagine a village fête in the heart of the city. Invite everyone to wear something red or blue or yellow or green. Wave flags.
 Here are some ideas for 'sports' on the day:
 * Strip the willow down Market Street.
 * Leapfrog down the High Street.
 * Choose a close. Run up it and down it as often as you can. You will be the record holder until you can ascertain that someone has done it more often.
 * Host three-legged races in similar closes. 'Oh, no! Look, they've fallen again!' 'Ooh, that crack on the step – was it her head?' 'Yuck, is that a broken shin bone sticking out?' Competition only ends when all the participants are bleeding or have broken bones. Photographic record leads to the exhibition – *Stones and Bones*.
5. Have an ecumenical service in the village church, St Giles, with the theme of neighbourliness. Follow it with a Sunday lunch, like in the old days.
6. Greet people using the Neighbourhood Phrasebook. For example:
 * Look at the cranes. Aren't they majestic?
 * Those closes seem to be getting steeper! Don't you agree?
 * Excuse me, are you looking for the Castle? I thought so.
 * On a clear day, you can see all the way to North Berwick, *un petit village au bord de la mer, ou les falaises sont dangereux a ceux qui essaient (?) les escalader.* (O Grade French 1966).
 * Can't you just feel *HISTORY* oozing from every stone? I thought so.
7. Imagine, beyond the boundaries of the village, green fields, a (Nor)loch, a corncrake like a baby crying. (Have you ever heard a corncrake? It's more like a baby choking!)

8. Host a meal to which all cultural organisations in the neighbourhood are invited. Have conversations like these:
 a. What have 'we' to gain by identifying as a neighbourhood?
 b. How might seeing ourselves as part of a neighbourhood affect our practices?
 c. What are the different values of 'bonding social capital' and 'bridging social capital'?

9. Imagine, in fact, that the neighbourhood is a campus. What might be taught/learned here? What facilities does it offer?

10. Start a Neighbourhood Guest Book around the Station, the taxi queue, the High Street. Invite 'Comments'. Give thought to the different conversations you have with those passing through compared with those who live/have a stake in the neighbourhood.

11. Start a neighbourhood mobile (ie carrying the books) library/book club for the homeless. Seek donations of books.

12. In a suitcase, place five art objects in two or three dimensions. Invite people to choose their favourites. Have a conversation about 'art'.

13. Bang the drum for the neighbourhood. March around the neighbourhood banging a drum and giving out favours. Any number of participants, any kind of drum. Other instruments welcome. Mood can be sombre – accompanying someone to an execution, mourning a plague victim – or joyous, even ecstatic. Favours can be tiny poems, images or tokens for Jenners' last days.

14. Find a place to plant something. Plant it.

REBIRTH!

It is a large building that had stood empty for some years. Before I was born, it had been a market of some sort, specialising in fruit and vegetables – fresh farm produce – brought in from the surviving collective farms and allotments. But no use had been found for it lately, till an order was issued that, on account of the plague, the streets were to be cleared immediately of the homeless. Crude wooden bunks were built inside the old market. The homeless were gathered from the crevices, the overhangs and the tunnels, where it was known they passed the cold nights, and brought to the old market. They stayed there, living on soup and bread, till accommodation could be found that would keep them out of mind till a common cure could return them to their begging.

The old market was by now a prime site, for the hospitals were at breaking point and new spaces were called for that could be easily transformed into wards for the afflicted. The shaky wooden bunks were removed and iron beds and medical materials introduced. In spite of dedicated nursing staffs, death tolls continued to mount everywhere – in the ward of the old market no more than anywhere else. Nevertheless, reason was anyone's mistress at the time and it was suggested that the old market was too hospitable to infection – its rough brickwork could not be scoured. Alternative, more suitable, wards had been improvised at the airport and at the docks. The extant patients were evacuated to one of these and the building cleared once more.

The final purpose of the old market, in the dark times, was as a mortuary. As a mortuary, it had universal approval. After all, there is little need to prevent a corpse from coming into contact with another corpse; neither has anything to lose. And so these prematurely 'fallen fruits' were brought through the silent streets and stacked in a place where an account could be taken of them before their final dispatch.

The old market was not alone among the buildings and the streets and the neighbourhoods that needed memory to settle before it could be reborn. But, when it was, as a contemporary art gallery, the news was greeted with surprise and delight. Rebirth! At the opening of its first, carefully chosen, exhibition – one which favoured sensuous over intellectual pleasure – the new director spoke of a building that had known seasons of growth and seasons of tragedy. She was proud to be inaugurating a fresh season of growth. Everyone balanced their glasses of wine and clapped with the rapture of forgetfulness. But I know, from the many comments Magda carefully copies out and sends to me, that I am not alone in being unable and unwilling to forget the present building's provenance.

'Thank you for this exhibition. I shall come again.
I expect to learn new artists' names, yet always
for the art to vibrate with a feverish life –
as if each mark is prized
from the dark-edged frame that holds it.'

'I love it here!'

A FOUND POEM OF FEELGOOD FLUFF
TO LET YOUR EYE FLOAT OVER

I'm always glad to drop in and see what is going on in contemporary art...the café is excellent – especially their cakes...top notch...brilliant, great...I love it here!...can't complain...a great place to meet friends...one of my favourite places to be...pleasantly uncluttered...I like the light upstairs...delicious ovaltine!...the more I saw of it the more I liked it...the café serves scrumptious food...great! I like how the focus is definitely on the art...we popped into the gallery knowing it was a nice place to get a good cuppa...thank you, keep it up...the atmosphere is cool, you don't feel like you're being watched all the time...can't us grown-ups have a chance to do a bit of painting and playing with paper and glue?...fabby doo!...it is so easy to walk in off the street spontaneously and enjoy...I will be very happy the day I get a show here!...the café looks good though I didn't try the wares...I fell in love...the café smelt great although I did not actually consume anything. splendid!...I like a good debate. what is art?...thematically fluid...the multimedia room was a nice touch...I finally ventured inside!...I am always happy to get to know artists I've never heard of before... keep going!...bookshop: I haven't visited it yet. will do so at the end...excellent home-made cakes...love the stuff upstairs...the florentines are yummy!...I can colour in too...I liked it even though I'm nine...keep up the good work!...I like the white, it calms me down...you can spend half an hour and see everything in depth, or just pop in for ten minutes on a whim...keep exactly as it is!...I came more for the café, but the exhibition is quite good too...meeting friends for coffee after their wedding...I prefer upstairs to downstairs...student discount, yay!...the café makes the place smell good...the benches are placed appropriately too...I like the sparseness...ten out of ten – beautiful work and yummy sandwiches...the gallery leaflets were nice...good delivery of pictures...I like what the Fruitmarket does...we can never leave as one of us is always reading a book...just lovely!...

am I missing something?...

Antoni Tàpies answers the question –
IN WHAT WAY DO YOU THINK ART IS USEFUL TO SOCIETY?

We are living in a world filled with distractions,
a world in which the alienation of the individual is constant.
In a situation like this it's vital that we learn to recognize ourselves
and face up to our own nature. Before you can do this though,
you have to be familiar with what has already been thought
about humankind and life and even about art. I understand art
as a compendium of human wisdom
whose purpose would be similar
to that of certain religious exercises in the past.
But I don't think that an iconographic account
of that wisdom would serve this purpose today.
Art should incite people to achieve
a real state of contemplation. It's not a question
of learning the Declaration of Human Rights by heart
or anything like that. Instead it's a way
of producing experiences of absolute knowledge.
That's what I am trying to do in my work
and that's exactly why I think it has a useful dimension.

LET'S DIE FOR A PICKLED CUCUMBER AND THE WORLD REVOLUTION

from *Red Cavalry*
by Isaac Babel

NEON 2

THE FRUITMARKET COMMUNITY GARDEN

'The time is out of joint.'
 William Shakespeare, *Hamlet*

Ahead of schedule, the community roof garden was furnished just before the virus struck. A membrane had been laid which would hold soil and roots; water capture and drainage were assured. From the street, to every displaced taxi drivers' annoyance, pulleys had brought up the tons of soil, compost and gravel that would be the bedrock of the garden. Then the materials to give structure had been hoisted: the railway sleepers that would hold the beds of herbs, salads, brassica, legumes and fruit. Tractor tyres to be used for wild flowers, as they rose, spun in the air. Next was wood for a shelter and the materials for a potting shed and a small greenhouse to be constructed on site and placed according to plan. Two bee hives would take advantage of the wild flowers.

soil, wood and water
we breathe each of these in turn
with new reverence

 *

we throw out our nets
over this small inland sea
what we catch we'll share

 *

what lands tomorrow
in each element is bound
by imagination

 * * *

A call went out to the neighbourhood for anyone willing to tend a seed or a seedling till conditions were suitable for it to be planted in the community garden. The pots were delivered, with instructions for growth, to flats, to shops, to cafés, to bars. Different dates were given for the actual planting, depending on the nature of the plant. Soon after, what we all feared happened; the death toll from the virus meant lock down for us all.

if you lived alone like me
you would not ask how it is
that green tongues can speak

*

each day we bicker
and yet the seedling holds us
within its silence

*

lavender and mint
the fields of Provence; a glass
of tea in Turkey

*

the empty café –
fig at the window
a child watching rain

*　　　　*　　　　*

A few weeks passed and the date arrived for most new growth, apart from
the fruit bushes and the fruit trees, to be planted in the garden. A trolley went
round the neighbourhood and collected the small plant pots with their insistent
growths from the front doors of tenements, shops and so on. They were taken to
the garden and planted there by three volunteers with horticultural experience.

how ridiculous!
I was fostering beetroot –
and yet I felt loss

*

there was no benchmark –
we had done our best, yet still
we imagined judgement

*

the empty city –
kneeling, I tamp the soft earth
around the young thyme

When it came time for the fruit bushes and fruit trees, because there were fewer than the other plants, it was felt that the hosts could plant these themselves, three on the roof garden at a time and with guidance. The queue along Market Street was naturally socially distanced. I had an apple seedling and took my place with the others, quietly, each of us acknowledging the plants we held as much as each other. I felt like someone from a story who might win a great prize: the hand of the beautiful Princess Tsuki. I shared the story with my apple seedling.

to see the city
again! I bring it apples
I bring hope for growth

 *

Walter Scott is my witness
I commit my green fingers –

yet she holds her quince
as if it were her heart and
never looks my way

 *

a seagull heading for Leith
how far the sea light reaches –

pears cherries and plums
I would bring you all of these
wrapped in light from Leith

 * * *

We had to have faith that growth was taking place. We trusted the gardeners, what else can you do?, and the photographs they put up on the skeleton site. Yet it was all too general: they could not show us what we wanted to see most – how the one plant we had invested in was growing. When would we see buds, blossom, the small fist of a cauliflower, the ragged leaves of kale? And then, it seemed to us that disaster struck – a heavy fall of late snow.

no one ever imagined the terrain on this journey to be flat each morning we
woke to something that had shifted in the night we lived with peaks and troughs
dreaming of the trains we hadn't caught of the flights that had gone without us
we didn't quite feel ourselves we couldn't keep our feet on the ground sometimes
we were here other times there (neither here nor there were we at ease) we
read the screens we talked to the screens but missed the feel of earth through
our fingers if we stood on tiptoe perhaps we could see over the horizon or as far
as the following week
 and then the snow fell and then when the snow fell it was like
an avalanche had blocked our route there was no way through but so beautiful
the silent streets the small birds the grey city landscape a dazzling white and
our garden as if it were an altar an offering to the startling moon

beneath the white quilt
my toes rub against your toes
frost will not touch us

 *

it was a lesson
growth can happen through hard times
snow-peas broad beans leeks

 *

once all the snow has melted
the city is solid again

tiny buds open
and birds collect for the nests
beak and breast will shape

 * * *

After the 'avalanche', our hopes never dipped so low again. The garden was like
a banner we all lined up behind. By the time the virus passed, the young garden
was at its fullest growth. Bees were busy at the wild flowers, birds had laid their
eggs. That first year, there was little fruit from the trees or bushes – the famous
apple and cherry pies, the gooseberry and blackberry tarts would have to wait
another year and more before the boughs drooped with apples, pears and
plums. But did anything ever taste better than the soups and salads with which
we celebrated the garden's first year? Since then, a committee has worked hard
to involve the whole community – every age is welcome and there is a task for

each; the toddler poking a seed into the earth, the wheelchair bound old person weeding, as she leans over the raised vegetable bed. The Princess and I have two children now, each a little artist and a little gardener. I couldn't have seen that happening back then or seen the effect that the garden would have. People often ask, What is it that gives the produce its distinctive taste? We answer, this garden has its own *terroir* – it is a mix of where it is, of the light and the wind that touches it, of the soil that was first brought to it and became one with it. It is also partly a product of the cultural *terroir* that surrounds it; of what creativity brings to it; of the lessons it teaches in the softest most insistent voice. By some alchemy, this results in asparagus spears that taste clean, moist and that offer a perfect, slightly resistant, crunch and that taste of green and of *earth*. And if you haven't done so already, you really should taste our honey!

I need to be wary here
of saying more than I know

but there are places
and pathways I have known that
hold me to the earth

 *

so pleasant – oregano
and rosemary scented air

and look! the blossoms
of the fruit orchards lighting
up the old nor' loch

BRICKS AND MORTAR

Each of us is born running towards a park.
Many of us will do our best work before we get there.

Waking to a blue haze, the forecast uncertain.
I'm used to sitting wondering what might come next.

We hack at bricks and mortar, keep finding more rooms.
On the other side of the iron door lies the one we can live in.

'If you're feeling anxious, frustrated or overwhelmed,
you're not alone in that. Phone a friend for a chat.'

I set out my wife's breakfast – blueberries, grapes,
I cut the banana and put the slices in a ceramic smile.

'Nothing is random; nothing goes to waste.'
For example, 'Pomology' – the study and cultivation of fruit.

Remember that cobbled courtyard in Venice? Brick, rust,
a clothes line. A door. Silence. Each breath a mystery.

This 'craving dedication for change'. *Grant me*
Paradise in this world; I'm not sure I'll reach it in the next.

CRANES
at the St. James Centre

The cranes have been with us
for several seasons, building

the concrete nest to render them
redundant. We've loved them

among us, brasher than all our
dull monuments. Not far from here,

in my all boys school, at sixteen,
we read of Spender's pylons:

'Bare like nude, giant girls that
have no secret.' We freed the image

from its source: it flickered
through the day. Later, we learned

to write down how it showed
the way newness had entered

the poet's world. The cranes speak,
mostly, of money. Though today,

a crisp autumn day, towering
over us, disdainful of all

but their own kind, I recall
a heron, frozen at a weir, close

to a riverbank, unperturbed
by my presence, as it brings legs,

breast, neck and beak to bear
on a patch of slow, dark water –

each move calibrated within
its small windowed brain.

KEEP ON LOOKING UP

Group poem initiated by Tom Pow for Writers' Shift *event in Bookmarket, Waverley Mall, 20 November 2019*

Tom Pow

Keep on looking up
Keep on looking up

Though the road cracks up beneath you
Keep on looking up

Though all are glued to i-phones
Keep on looking up

Though words are losing meaning
Keep on looking up

Keep on
Keep on
Keep on
Keep on

Keep on looking up

Janette Ayachi

Keep on looking up
Keep on looking up

Paris is burning cathedrals
Keep on looking up

Opt for the tops of trees
Keep on looking up

Arch over rooftops and crates
head-tipped like a smiling sphinx
jaw-cracked like car-boot china

Fill your irises with stars
Keep on looking up

Keep on (x4)
Keep on looking up

Iain Morrison

Keep on looking up
Keep on looking up

When the phones are Cardiff Miller's
Keep on looking up

Friends, facts and fictions
Keep on looking up

Numbers, lists and rotas
Keep on looking up

Keep on (x4)
Keep on looking up

Jane Goldman

sorry i-i don't
have it in me
to look up

being one who tends
to the chthonic
it's not just

the up-ness either
i-i prefer ways
of seeing

Callie Gardner

Keep on looking up
Keep on looking up

No ticket in your pocket? well
Keep on looking up

Nonchalantly pass the guard
Keep on looking up

Art's sky-pinned, lonely there, but free,
Keep on looking up

Keep on (x4)
Keep on looking up

**Jane
Goldman**

over the looking
look within woolf
said i-i don't

hold even with that
last night head down
against iced wind

i-i met eight women
asleep on a concrete
concourse between

corporate offices
one awake saw me
said we're family

see them out begging
on pavement slabs
every day

this is our city
of sudden vistas
alright

when will the light shift
or the sky change
doesn't your heart

just keep on breaking

**Tom
Pow**

Keep on looking up
Keep on looking up

Why stop now?
Keep on looking up

We're only just beginning
Keep on looking up

A sign will surely come
Keep on looking up

Keep on
Keep on
Keep on/
Keep on/
Keep on looking up

Fruitmarket Staff Poems

Communal poem

common
pink with pleasure
above platform eight
stillness echo community
working with
reach
response
people challenge change
metallic glassy stairs
tenacity
white pink light
windows doors
obstacle building
unblocking

Kate Livingstone
Information Assistant

After *Tacita Dean: Woman with a Red Hat,*
7 July – 30 September 2018

Two things brought together
in the body of the camera
(The) ending of a sad film that never existed.
Cut + paste + mark making
(a) film is made in darkness.
Don't disrupt others
book through event bright.

The Usher
The Projectionist
a living, breathing medium.
58 minutes. BUT use discretion
(because) you are part of the work
Muse/Tempest
Each … is like a grain – a snowflake.

Lithograph
Monoprint
An electric pulse(s)
The importance of forgetting conscious thought
(and that) erasure is not deletion.
Tragic endings (are) back projected.
Thinking theatrically – an art in its own right.
ON – mains on
– select forward
OFF – STOP
– mains off
Daydream is gone.

After *Jac Leiner: Add It Up*,
1 July – 22 October 2017

It's almost nothing
skin – rebel (and) formal concerns.
Activities that help us think
that focus the mind – to pass the time.
Pigment/Patience? Water/Time
'To let time go'
'To work time'
Smallest to largest,
colour organisation,
worthless banknotes – No! They were circulating – so it was a crime.
25 year old bubble wrap
(like) cells of the bodily organs.

(The) metaphor of light
(The) journey of life
(The) ups + downs

The work is yours,
(and) the levels are working
to prevent secondary theft.
Looks like a minimalist painting,
2005 it was first made (and) exists in several sizes…
Things which would have been discarded
(+) have been saved
they become the stars.
People see things in other things
like faces in (the) clouds
The work belongs to the world.
The Artist's story is folklore.

Elaine Kilpatrick
Bookkeeper

National Import Relief Unit
NIRU
Relief Unit Import National
RUIN
You should send us documents
We may charge you
Tell you about this
Public Notice 301, Section 23 of the Finance Act 1994, Article 15 of the Union
Customs Code.
Go to www.gov.uk and search.

Catherine Hiley
Duty Manager

Please perform this transfer
 Sony Germany are now refusing to let the
 bananas we have selected for your exhibition
 to travel to London between Cologne and Berlin. We have to hire equipment
 offering many different architectural forms
 which raises the cost
Please perform this transfer
 Did the Flemish Ministry of Culture decide to
pay this amount
 to both venues?
Please perform this transfer
 to Edinburgh

Lindsay Boyd
Duty Manager

out and up

opening out
looking up

growing out
holding up

planning out
measuring up

building out
connecting up

holding out
signing up

speaking out
standing up

falling out
making up

printing out
typing up

facing out
putting up

coming out
speaking up

putting out
breaking up

clearing out
tidying up

losing out
acting up

keeping out
building up

phasing out
stepping up

hanging out
catching up

shifting out
moving up

painting out
covering up

booking out
filling up

moving out
closing up

signing out
cashing up

order

online order
running order
following an order
last order
change order
standing order
retain order
regain order

Ruth Bretherick
Research and Public Engagement Curator

Between things

Leaving the old Fruitmarket, walls lined with
Papers for the *Annotated Reader*
Installed together, like Wallinger's strings,
A hundred reef-knots on a hundred chairs.
An early job in this new role, I love
The way these people are reefed by art work.
Then all those papers, a hot gallery,
And me, trying to find the coolest corner
For my big belly. I left boxes packed,
And notes for my colleagues. See you when we…
But we didn't. See you online, see you
One to one in a leafy park, see you
In a hardhat and boots, mask on. See you
Soon, I hope, between sculptures, between things.

Natasha Thembiso Ruwona
Duty Manager

After *Senga Nengudi,*
16 March – 26 May 2019

a black body is only visible in the night
always visible against light
the world i exist within is consumed
by black
and
by white

how can my body shape shift?
shrink and stretch
to whatever i see fit
my performance
entitled
"code-switch"

a body pinned to a wall
left to hang and then to fall
our strange fruit ripened
then consumed
by all

how do the whites of walls highlight brownness and blackness? (x3)

each person has a use
for a colonised body
each person has a use
has a use

if i imagine my body
in the form of tights
brown – hard to find.
stretched. tired. fragile.
yet secure and strong
springing back to life
then
continuing to rise.

what does it mean to have a multi-purposeful body?

sand weights
don't wait
to weigh
me
down

when hurston said
'i feel most coloured when i am thrown against a sharp white background'

she put it best.
how does the gallery reflect
you?

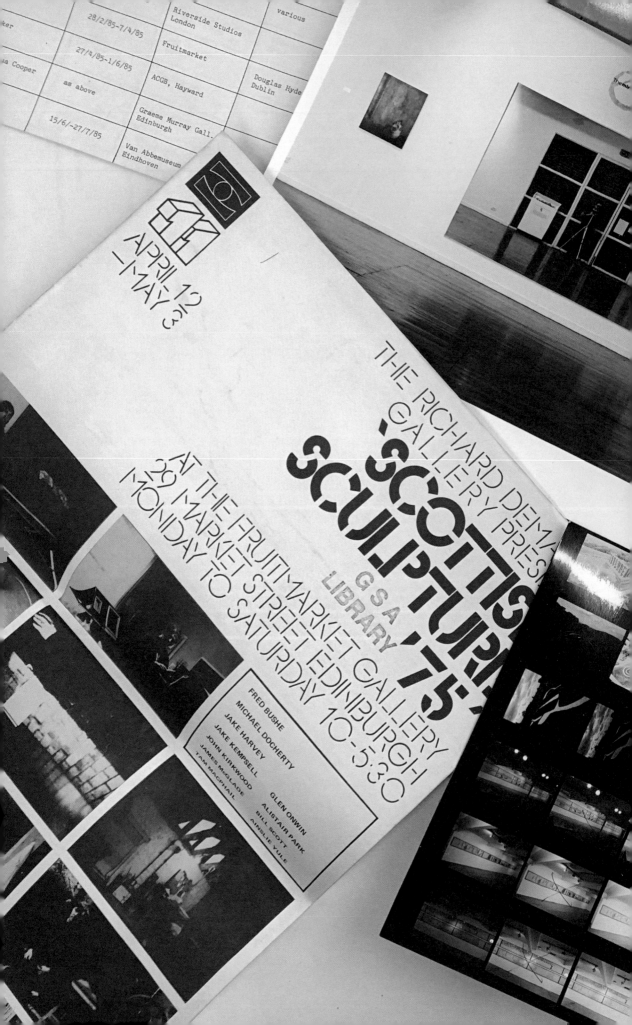

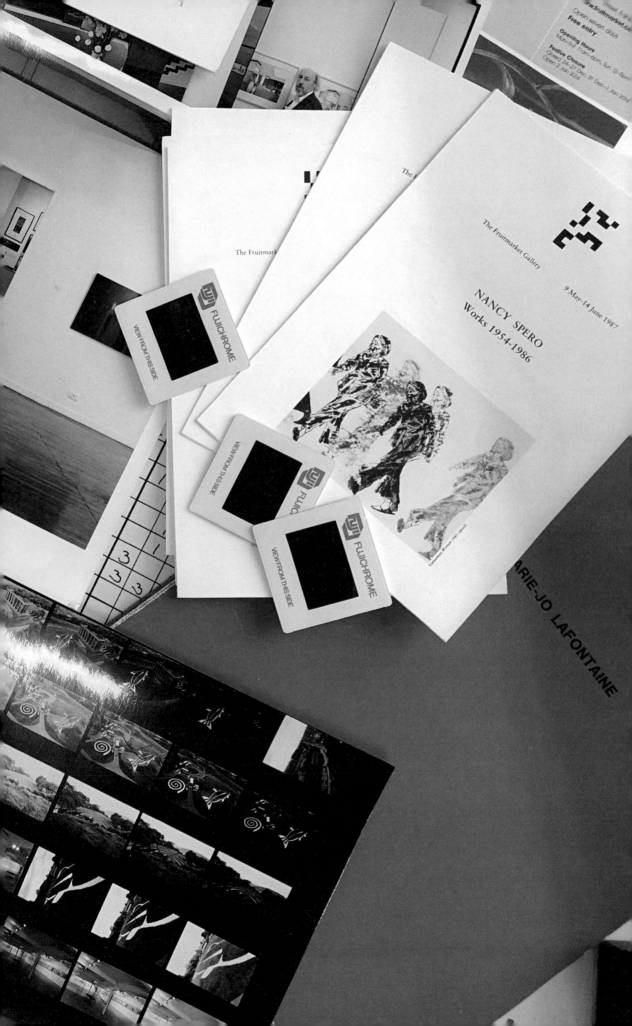

Archival ebbs and flows

Ruth Bretherick

We did not know what to do with all these boxes, full of files about half-remembered exhibitions, photos of events, performances and workshops, all slightly unsure of themselves. Occasionally someone sent me an enquiry and some of these things came swimming into view. But this, *Writers' Shift*, has invited waves of memories to flood back.

Archives often invite metaphors of archaeology, of digging and unearthing. But perhaps a more appropriate metaphor is that of water, for the ossified rocks of archaeology suggest too much permanence. Like the sea, the Fruitmarket archive has shaped and has been shaped by that which surrounds it. It has survived transitions, fires, and neglect. Tidelines of damp and soot mark some of its pages. Since the Fruitmarket has never had a dedicated archivist, interest in the archive has ebbed and flowed. You find in it the periods at which there has been a small pot of money or a bout of enthusiasm by a previous staff member, when they were able to label up some boxes, type up some interpretation leaflets or hold an event or two talking about the gallery's history. *Writers' Shift*, I think, will leave a bigger tideline.

When I first started working at the Fruitmarket in 2016 I was not appointed as an archivist, and nor is that my training. But, as an academic,

a researcher, I was itching to look at the archive boxes stored offsite. My colleagues told me they were not much to get excited about, and so it was forgotten for a time. It was not until I started organising our library – 'collection of accumulated books' is perhaps a more accurate description – that the question of the archive arose again. I began to talk to archivists at other institutions, working out how to make what we had not only useful to researchers but inspiring to artists. It starts, very practically, with knowing what you have, and knowing how to find it. We did have records of the contents of our boxes, and we did have a list of exhibitions dating back to the 1970s compiled meticulously by one of my colleagues, but the link between the two was not always obvious, so I made it my task to compile a database that would easily show our exhibition history and any information we had about it or could point to. The resulting database – which proved so useful for the Shifters – was created slowly and steadily, filling in gaps as I found out more, knowing it would never be finished, and that everything I recorded could be subject to change and might also risk replicating errors from previous records. The beauty of *Writers' Shift* is that it made this very laborious and somewhat dry work immediately worthwhile.

I had two simple aims in my sights: to make our exhibition and events history more visible and accessible; and in the context of the building redevelopment, to wrap our past into our identity. Before *Writers' Shift* began, we appointed a paid intern to help us reach towards these aims. Tom Day joined us from the University of Edinburgh, funded by the Scottish Graduate School for Arts & Humanities in the summer of 2019. His brief was to 'focus attention on a section of the archive and devise ways in which to make this material accessible and relevant to the public'. Tom was just writing up his PhD, which was about film and video art since the 1960s, and approached our archive with this expertise under his belt. He chose to focus on exhibitions of moving image work, and in particular on the 1979 exhibition *Eye to Eye*, which showed the video work of Tamara Krikorian, and was the first solo exhibition by a female artist at the Fruitmarket. Not only did Tom produce thorough research into his chosen exhibitions, he also got a handle on our whole exhibition history – about 300 exhibitions – and did remarkable work making connections between our archive and those of other organisations. Where our archive has gaps, he found places to seek out the missing information. And Tom was able to brief the Shifters on everything he had learned during his time with us.

Tom's was an academic engagement with the archive, but I knew there was potential to welcome artists and poets to engage with it, particularly with such practices having a significant history in contemporary art. Jacques Derrida's 'Archive Fever: a Freudian Impression' (1995) and Hal Foster's 'An Archival Impulse' (2004) both inform and map an engagement in archival practices and aesthetics that have grown in contemporary art and culture since the late 1960s. In recent years, museums and galleries have been actively

inviting artists and writers to probe and respond to their historical records, stretching the reach of the archive beyond the world of the academic, not only to engage artists but the audiences they inspire.[1] *Writers' Shift* falls into this lineage, fueled by a shift in the Fruitmarket's history – a moment of transition into a new building – looking back to help us move forward. Indeed, as much as it is about the past, archiving is a curiously forward-looking and optimistic activity, storing things for the future.

An archive without people is dull. And often what is not recorded in our archive, except perhaps fleetingly in the odd retained comment book or survey, is what visitors actually thought, actually felt, when they came to the Fruitmarket. For *Writers' Shift*, Iain Morrison deliberately chose poets who had pre-existing relationships with the Fruitmarket and could think about how the exhibitions 'sit interleaved with our personal memories' as he put it.[2] These writers bring their own memories to bear on the papers, clippings and slides that populate our boxes. Tom Pow put it beautifully when he said: 'We're all interested in the idea of the gallery as a social infrastructure. We're interested in the idea that it wasn't just a gallery: it was the café, it was the bookshop, it was the ambience, it was the whole package—the gallery in the neighbourhood.'[3]

Writers' Shift has brought the experiences of individuals back into the Fruitmarket's exhibition history. But it has also given the organisation a way of talking and thinking about past programmes as part of our identity now. We can confidently talk about moments that might not represent the way we would do things today, but nevertheless belong to our history and deserve scrutiny and re-evaluation. It has allowed us to own our past, and to reassess the way we hold and keep records.

The redevelopment has not only meant a re-engagement with our archive, but also the instatement of a new archive room, allowing us to hold our archive on site for the first time.[4] This is aptly located in the former Director's Office, where so many of the ideas contained in the boxes would have first been discussed. The room is open for anyone to book, and is matched by an archive on our website tracing our history back to the 1970s with images, videos and documents. The Shifters have shown us how to use a partial archive – how to read its ellipses and lacunae, how to imagine oneself into its gaps. I hope their work, and this book, will inspire others to come and do the same.

Due to maternity leave and the vagaries of furlough and working from home, I have been somewhat removed from the activities of the Shifters, but I have read what they have written, and about the conversations they have had, and the discoveries they have made, as it all washed up on the shores of my email inbox. I am almost overwhelmed by it, overcome by it. But maybe I know what to do with all these boxes now. Open them.

Ruth Bretherick is Research and Public Engagement Curator
at the Fruitmarket, Edinburgh

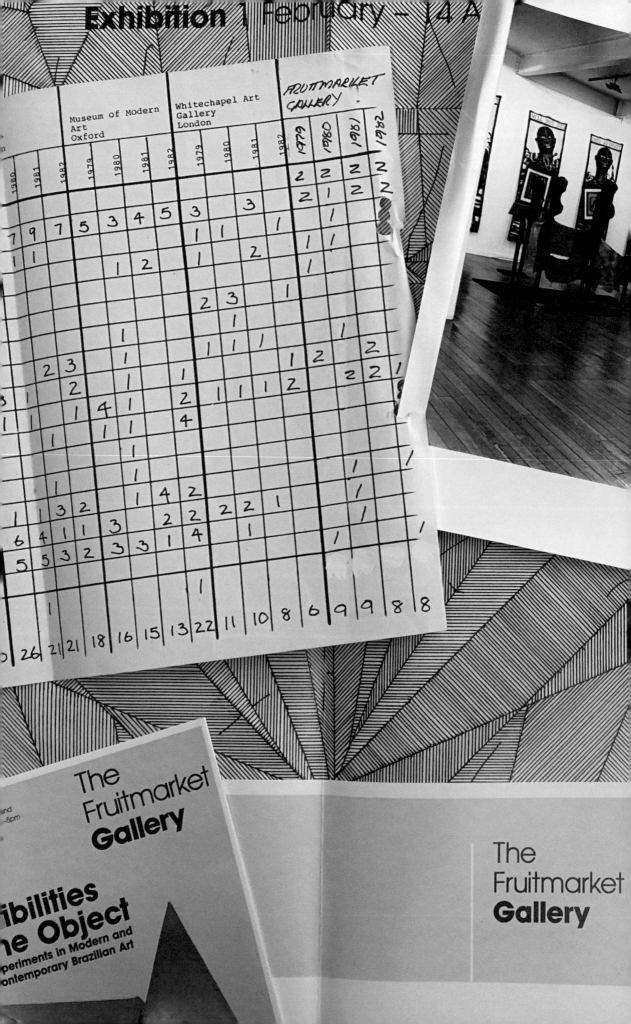

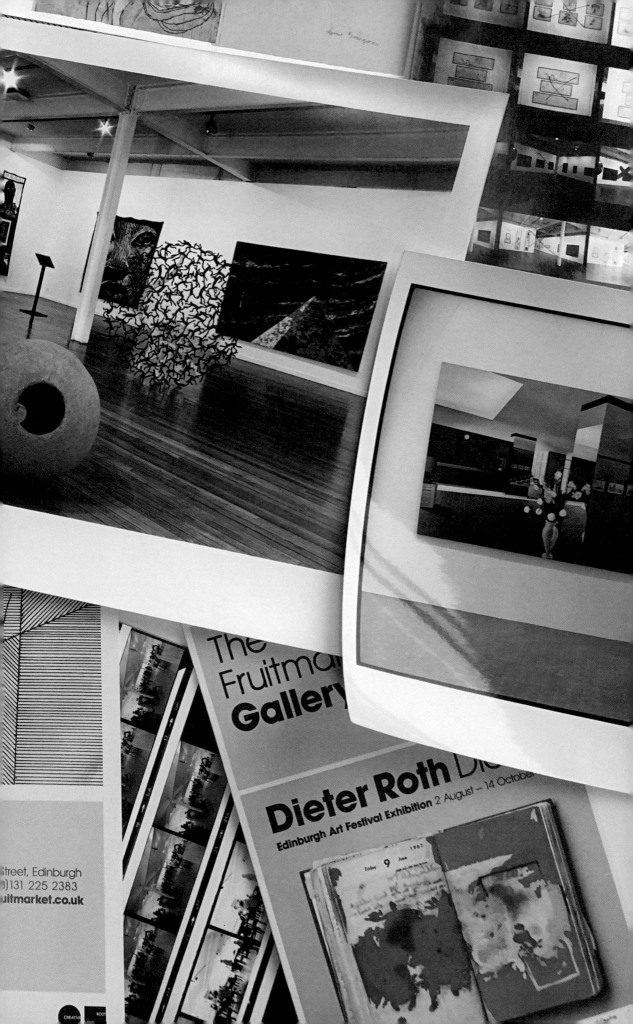

The Fruitmarket Gallery

Dieter Roth
Edinburgh Art Festival Exhibition 2 August – 14 October

Street, Edinburgh
)131 225 2383
uitmarket.co.uk

Hidden Archive, 18.11.20

Transcription of Shola von Reinhold's response to the Fruitmarket's archive[1]

I am not used to archives. I am not an archivist by any stretch, nor a historian, nor a scholar of the archive, but I have recently been pulled into the orbit of archive talk because I wrote a book[2] out of which archive rose up necessarily as a conceit, as a device, as a dream on the one hand and on the other as what Saidiya Hartman terms 'critical fabulation'.

My first experience with a traditional archive, whatever that means, came out of a curiosity to see the people I was reading, and then to see more of the people who knew these people but were not written about, who provoked a gossip's compulsion – a very good thing to have – about who constituted the initial figures' intricate or not so intricate social networks, shaped the social atmosphere they were living in. But these faces also loosed a kind of psychic charge made up of a deep and unsettling resonance with their anonymity, their marginality. So these secondary or tertiary figures would often end up overtaking, overriding, points of initial fascination. In those cases I would career around intuitively following faces that interested me; the trails would end or – if the faces were named or had their own boxes or folders, go on for months leading to yet more faces. But when it comes to actually using the archive consciously as a tool, a means of recovery, as a way of excavating or uncovering the unnamed or the unknown in ways that I have since tried to use them – with a view to seeking out, for example, African diasporic histories – they become unwieldy and downright antagonistic. The sheer volume and configuration of archives can quickly conjure up a feeling of bureaucratic violence, especially for those most on the receiving end of it.

Tina Campt famously talks about listening to photographs, about phonic substance, the sound inherent to an image that emanates from the image itself, and about listening as a methodology, which became for her one way of manoeuvring the vastness of the archive, of visual information, of the density or seeming paucity of information that issues from an image. My earliest (and to some extent continued) experiences of archives was maybe something opposite, outside or just different to Campt's process of listening because it entailed what I think of as a kind of optical glazing, an *almost* literal and literally literal glaze would appear over the photos. Three kinds of glaze actually. One, a kind of aura – a charge that I cannot describe. Alongside this another textural glaze: what was either me imposing a kind of romance onto the image, or an intervention happening between the image and I, orchestrated by history, or by my relation to the world, which caused gold clouds and halos to circulate over the photographs – something that would also happen with the written word to the extent that I was wasn't really reading texts, a hyperassociation where images got thrown up from the sounds of words. And then there's also the final optical glaze, or aura, which was because I have apparently what some people have and some people don't, and those that have, have on a sliding spectrum, which is called visual snow syndrome, perpetual fuzz or snow. So looking was mediated through a perpetual fuzz of snow, accompanied by halos as well,

and it's all a sort of mostly background noise but can come out even more strongly when I focus on photographs in particular. Photographs were noisy, but I wasn't listening to them in the sense that Campt discusses. But I wonder if these extra-mediations relate in some way to why critical fabulation – or maybe alternatively it's a *non*-critical fabulation – came so easily. To dream into the archive wasn't so hard when the archive was already an interrupted surface experience mediated by clouds of unreality, but also the archive was as much a cloud of unreality interrupting my line of vision already.

In this case, however, I have resisted the urge to fabulate, critically or otherwise. It was my first impulse when asked to respond to the Fruitmarket, but something overrode it. Instead, I decided to take the opportunity to just momentarily resurface something.

It wasn't long before I noticed in the Fruitmarket archive an entry for *From Two Worlds*, an exhibition which was held at the Whitechapel Gallery in London between the 30th of July 1986 and 7th of September 1986 before coming to the Fruitmarket on tour between 9th November 1986 and 3rd of January 1987. The exhibition was a notable and curatorially contentious point in the history of Black arts in Britain. One source calls it 'the most substantial exhibition of Black artists' work at a major London gallery to have taken place'. I mean, there was also the likes of *The Thin Black Line* at the ICA, which was curated by Lubaina Himid I think the year before the Whitechapel show. But anyway here's what the Fruitmarket archive entry says about *From Two Worlds*.

'*From Two Worlds* included works by artists all living and working in Britain but from a wide variety of cultures spanning Africa, Asia, the Caribbean and the Middle East. The participating artists were the Black Audio Film Collective, Saleem Arif, Denzil Forrester, Sonia Boyce, Franklyn Beckford, Sokari Douglas Camp, Veronica Ryan, Zadok Ben-David, Shafique Uddin, Tam Joseph, Rasheed Araeen, Lubaina Himid, Gavin Jantjes, Houria Niati, Keith Piper and Zarina Bhimji. This was the first time many of these artists were shown in Scotland.

The exhibition was premised on the notion that all of the artists drew 'a common inspiration from the reconciliation of the two worlds to which they belong' (Fruitmarket exhibition guide, 1986) and it aimed to increase the awareness of the contribution to global culture that these artists were making. It included painting, sculpture, drawing, mixed media and audio-visual pieces.

The exhibition toured from the Whitechapel Gallery in London, where it was selected with the assistance of Sonia Boyce, Gavin Jantjes and Veronica Ryan. It was accompanied by a catalogue with an introduction by Nicholas Serota and Gavin Jantjes and an essay by Adeola Solanke.'

As to why the show elicited reservations, suspicions, cynicisms, these seem to issue mainly from its format: a Black focus survey show. This presented two main issues for artists at the time, especially Black artists. One was a wariness about pigeonholing, about being lumped in, as addressed by the art

historian Anjalie Dalal-Clayton's 2015 thesis[3] where she says 'the organisers of *From Two Worlds* stated in the catalogue introduction that some of the artists they had approached for inclusion had declined the invitation perhaps fearing imposition of an "ethnic label"'. Similarly, Araeen acknowledged that there had been artists who refused to take part in *The Other Story*, which is another survey exhibition[4], stating that 'making an exhibition on the basis of racial origin is not something that comes easily to the art world. A number of important artists felt unable to participate, wary of a context for reasons which are perhaps understandable'.

The other not unrelated anxiety was that the thematization of the show was a superficial way of not calling it a survey show and ultimately portraying an underlying curatorial disinterest, maybe even foot-dragging on the Whitechapel's part. Dalal-Clayton goes on, 'perhaps in response to mounting criticisms of the Black survey curatorial format, the Whitechapel staged a survey of work by Black artists in 1986, titled *From Two Worlds*, which its organisers boldly asserted represented a departure from other preceding and contemporaneous Black survey shows, through having been devised in accordance with a theme and not simply the artists' non-white ethnicity. The artist Gavin Jantjes and the then director of the Whitechapel Gallery, Nicholas Serota, had selected the artists for inclusion in this exhibition because of a relationship of the work to the theme of cultural plurality and the fusion of European and non-European visions. They suggested that this theme had enabled them to focus on instances of cultural synthesis as opposed to cultural difference, which other Black survey shows had emphasised as a result of being devised in accordance with the limiting ethnic labels of Black, Asian or African Caribbean.' On this note it is worth looking at what the art historian Eddie Chambers, closely linked with many of the exhibiting artists at the time, said in an article entitled 'A Bizarre Form of Anthropology', and this appeared in the 'Race Today' review in 1987:

'The more times I read the introductory essays in the *From Two Worlds* catalogue, the less convinced I become as to the stated premise on which the exhibition rests. In simple terms, all this talk about Black artists, or even more importantly, some Black artists', I guess because it wasn't totally black artists, and they were under the sort of aegis of political blackness as well in the '80s, 'coming from two worlds is unconvincing and unsatisfactory. *From Two Worlds* amounts to nothing more than just another survey show. The organisers appear to be stubbornly reluctant to admit this. Instead, they choose to couch the exhibition in a quaint, half-baked theory that lends itself more to a bizarre form of anthropology than it does to arguments about Black visual creativity. If the exhibition had been entitled 'Essentially Arbitrarily Chosen Work by 15 Essentially Arbitrarily Chosen Artists', then harsh criticism would to a large extent have been unjustified.'

And then Chambers goes on to say 'in 1986 naïve notions of cultural pluralism, and mutual aesthetic exchange just won't do. On this earth, there are no such things as separate, autonomous worlds.' And it's quite interesting because Dalal-Clayton mentions how Eddie Chambers, who wrote that review, went to a meeting at the Whitechapel Gallery about this show, and he said instead, 'Why don't you actually just stage exhibitions of individual Black artists?', which they didn't do.

But given all of this it's interesting to think about what this means in a Scottish context. If Black-centred survey shows were getting tired as a strategy in England, they were still considered as having a place. To quote Dalal-Clayton again, 'because of its widespread adoption by the mid-1980s, the Black survey show had successfully demonstrated the extent and variety of Black artistic practice in Britain.'

So how did *From Two Worlds* translate to Edinburgh since, if we are to believe the exhibition guide information, this was the first time many of the artists had exhibited in Scotland. And I only have more questions from here, things I'd like to be made accessible through Fruitmarket be it on the archive or elsewhere, and they are: What did this mean for Afro-Scots at the time? How many of the exhibiting artists visited Scotland at the time and what were their experiences of visiting Scotland? We do know that Lubaina Himid came to do a talk, for example, how many Black people saw her talk or came to the show, or who came to the show? What were wider reactions to the work or to Lubaina Himid's talk and to the work, which I haven't given myself time to mention? I was going to describe as many of the pieces as possible but I haven't had time to do this justice because, well, the work was quite spectacular and quite dizzying to comprehend even just from looking at the black and white photograph image which shows Keith Piper's mixed media installation in one corner.

And I'll just end quickly with a quote on archives from a recent event with Jordy Rosenberg[5]: 'Some archival work has a presumption that if a body can be found, then a subject can be recorded. But the thing about history is that it doesn't move in a linear fashion, it doesn't move always in a legible way, and we can't assume that bodies that we find in this past are legible precursors to our contemporary forms of subject, our contemporary forms of subjective. There are aporia, there are huge historical gaps that exist, and so we don't always want to encounter the archive as looking to establish.' Thank you.

Hidden Archive, 18.11.20

Conversation between *Writers' Shift* poets and Shola von Reinhold

Iain Morrison [IM]:

It's quite hard to do this with six such different voices and approaches, but it'd be wonderful to get some sense of how what we've been doing together, and more recently also with you Shola, might contribute to the optimism and the assessment of the archive that you were talking about. I was struck by what you were saying, Shola, about how there's work that you'd like to see done at the Fruitmarket and other places. Was that just about wanting to recover more information about the experience of Black audiences and Black artists at the time of the *From Two Worlds* show? Or, you're talking about looping and connecting, how do you connect that to work that we might try to do now at the Fruitmarket?

Shola von Reinhold [SVR]:

I really don't know, it's just that it seems important to have those voices either referenced in the archive or accessible in some way, whether it's something adjacent to the literal archive document or something in the archive itself. It just seems like an important thing, and to my own curiosity, my own gossip's curiosity as well, especially with Black-centred things in Scotland.

IM: I'm connecting this in my head with the approach that we five poets have taken to looking at the archive, which is something that Callie, I think you said it to me first, that you were taking an approach that was following your intuition and being perhaps less completist than the approach a bunch of five academics might take. About how poets might give themselves permission to follow a more intuitive approach to the archive and less of a kind of bureaucratic completeness. Callie, I don't know if you want to come in on that.

Callie Gardner [CG]:

Yes, I had the opportunity to speak to the researcher Tom Day, who had done a lot of work in the archive and had been looking at it from more of a systematic, academic angle. And it was interesting because we were all able to draw something different out of the archive that a more academic-historical method might have missed, sort of panning randomly – not randomly, but panning with our own kind of tool, with our own set of interests and the things that we were we were attuned to pick up.

IM: How does that strike you, Shola? Does that resonate?

SVR: Very sonorously! I guess that when it comes to thinking about the Black African diaspora in Scotland, in the UK, and more widely in Europe, whenever I encounter things like this exhibition, obviously I'm transported to what would it have been like as a Black person at this time going to even the café, and then to wondering what artist experiences were. You know in my novel *LOTE*, which

I read from, one of the sparking points for the character Hermia Druitt was a real woman who was studying at the Slade School of Fine Art in London in 1919. I've told this bouquet story a million times, but Stephen Tennant and Rex Whistler burst into the Life Room of the Slade, that was then gendered so it was already shocking that two young men were coming in. They navigated their way through the easels, stopped, knelt and presented this woman with a white bouquet of roses, and the woman is described as black or specifically as mulatto. And even though she was just an anecdote to illustrate Bright Young antics in the 1920s, that figure grew and grew in my brain and I've now started doing the very early archival research to establish who this woman was. And one of the things I kept on thinking was simply that the resources to actually find what her life would have been like, what her daily experiences were, were quite inaccessible, even though there are lots of people doing work into this sort of thing.

Anyway, I was reminded of researching her and the fact that she probably would have gone to the 'Negro Exhibition', as it was called at I think at the Chelsea Book Club in around 1920. Jane, you probably know about it because I think that Clive Bell or Roger Fry had some sort of relation to it. And you know, this was heralded as one of the first Black-centred exhibitions, although the artists in it had far less agency than the artists in *From Two Worlds* because this earlier exhibition was much more about the spectacle of Primitivism and how it could be a launching point for Modernist artists. But I was thinking about this woman walking around *that* exhibition in similar ways to thinking of maybe someone like Maud Sulter going and walking around the *From Two Worlds* exhibition. I don't know if she was in Scotland at that point. I know she knew Lubaina Himid, and they worked together.

Jane Goldman [JG]:
Yes. The art dealer Paul Guillaume's collection of African sculptures (from the Ivory Coast and Gabon) came to London's Chelsea Book Club in 1920 having been first exhibited at the 291 Gallery, New York in 1913. They caused a sensation in both cities. And the Bloomsbury art critic Roger Fry praised them as fine art of the highest order.[1]

To pick up from that wonderful point about the kind of formal presentation of racial presence and the lack of understanding of the audience. Rather than just putting Black art on display, unfortunately it's all tied up in this word 'fine', where 'fine art' and the 'fine Negro' in quotes, are epithets attached to economic evaluation of both painting and human beings. And we're never very far from that in all of those discourses. I was saying to Iain, earlier on, how his poem listing the often just overtly racist reviews in the major national newspapers of Basquiat is coruscating, but it's nothing new. In 1910, Roger Fry and Clive Bell were responsible for the Post-Impressionist exhibition, *Manet and the Post-Impressionists* and the reviews in the press were similar; there was

a cartoon made by Henry Tonks taking the piss out of Clive Bell and Roger Fry in which Fry is shown to be worshipping this great symbol, and it's a symbol of a Black woman. And it's being presented like some object of ridicule. An interest in formalism has led these Aryan thinkers to the wrong kind of art and the wrong kind of representation of humanity. You just realise it's segregation on several levels. I think what you're identifying, Shola, is that we need also in an archive to look for the audience as well as the contents of the show. This is class ridden. It's about class apartheid, gender apartheid, and race apartheid and how does an institution rectify that?

IM: I want to give you credit Jane there because I think one of the wonderful gifts that your piece *ON GROWTH AND FORM (FIBONACCIS FOR LOUISE DICK)* gives us is that it does follow a woman's whole life, no surprise from a Virginia Woolf scholar perhaps, in the way that you take Louise Dick who's a real artist, art teacher, a person who first came to the Fruitmarket in the '70s with her teacher from Craigroyston school, a school we work with now. And you give a sense of optimism to us working, not with the archive, but with the institution so that we can offer support for someone's spirals, for someone's journeys and growth. I find that dizzying. And it seems to me that one strategy of *finding* the audience is literally finding the audience and interviewing it.

JG: Yes, thank you, Iain. I interviewed Louise Dick because she had worked in the Fruitmarket as a Gallery Assistant for four years in the 1980s after graduating from the St Martin's School of Art in London, and out came her stories about her formative experiences of visiting the gallery as a school girl years before. There's such a rich resource in the Fruitmarket. We've been engaging with it for a year and we've just plucked some low-hanging fruit here. There's so much more to do.

IM: I'd love to bring in Janette and Tom to see what they're thinking about this, and how this works with their strategies. Janette, did you find that you were recovering voices or inventing voices?

Janette Ayachi [JA]:
That's a great question. Something Shola was saying about the psychic charge of the archives, I felt that as well, the idea about the photograph being noisy, but I wasn't really paying attention to and listening to the noise it was giving off. Things that are left in the archives, that are wrapped up, that are mummified, they become potent in that immersion of themselves. So when you do unravel them, there is an initial, 'Oh, is this an Egyptian tomb? Am I cursed forever? Should I be touching this?' Should I be knowing really what should have been shown at the time and wasn't, and should I be taking that

knowledge into the way I'm reimagining the future of what it is that we want to showcase generally, in our art world, and in our literary world? So it's all completely tied in together. It was just so wonderful to have access to that which was not publicly accessible, to be able to delve in and immerse ourselves in it and listen to those voices that came before us, that left an imprint behind that sometimes just need to be lifted up from the screen and shown in a different light. So we can just recontextualize the idea that was there before and reimagine another way of showing it. I think this is such a wonderful time as well, when the Fruitmarket was already stilted, already halted. And then we were suspended a little bit longer. It was almost like there was something we were missing. And we had to go back in and we were given extra time to discover what that was. Without extra time I don't think we would have come to this conclusion at the end, of seeing that these archives are so valuable and need to be spoken about. Stories need to come forth, and we need to keep discussing it and reinventing new ways of seeing things because as the world changes, we upgrade and we shift and our perspectives change. We have new formations and new ideas, and as we feel them within ourselves we need to project them into the art and the work that we have, surrounded in our environment as well. So it's just been an absolute pleasure, and just to listen as well here today has been fantastic. It makes it even grander, doesn't it? You open up more portals, 'What's next? What's next?' It doesn't feel like there should be closure.

IM: I suppose there isn't, and I don't think there's anyone stopping you from continuing your amazing writing, Janette! Tom, how are you mastering tonight's technology? Are you still online with us?

Tom Pow [TP]:
Yes, I'm here. I was just thinking I was interested in the comments about audience and responses. As you know, I wrote a composite poem 'I love it here!' A FOUND POEM OF FEELGOOD FLUFF TO LET YOUR EYE FLOAT OVER based on comments in the comments book. And I sometimes say you can do a ticky boxy thing, can't you, and get responses from people? But to get something deeper is more challenging. If you read the comments, it becomes quite clear that people are uncomfortable trying to express what they actually feel and what they get from the work, what the work means to them. And so an awful lot of the comments are about how great the cafe is. You know, 'I always come in here', and the bookshop gets a lot of praise as well. My poem ends:

'I prefer upstairs to downstairs...student discount, yay!...the café makes the place smell good...the benches are placed appropriately too...I like the sparseness... ten out of ten – beautiful work and yummy sandwiches...the gallery leaflets were

nice...good delivery of pictures...I like what the Fruitmarket does...we can never leave as one of us is always reading a book...just lovely!...

am I missing something?...'

IM: Yes, are you thinking perhaps that we're all missing something?

TP: I'm thinking, probably, you know with the pupils that you engage with at Craigroyston that there's a deeper conversation. I don't know how you develop deeper conversations for people just dropping in, for them responding to work, getting these reactions that enrich the archive of responses apart from just reviews. It would be nice to know, wouldn't it, what the public who went to see the Basquiat exhibition thought of it, and some of these other exhibitions you're talking about?

IM: Yes, and that sounds like the sort of direction that Shola's interest was leading them. I hope we can encourage Shola to continue to follow that interest!

SVR: It reminds me of piece called 'THE MYTH OF "TRANSFORMATIVE" ART AND THE REALITY OF ART AS PART OF EVERYDAY LIFE'[2] an essay I found online which was thinking about the way that galleries present themselves as transformational, and how they're often forced to present themselves as transformational because of funding requisites and things like that, and how sometimes it's better for them just not to do that. Why pretend? This essay mounts the idea that at most they're interventions, they're not transforming anybody's life. The writer, Rosie Priest, who's working class, would go to galleries as a child with their Mum who was an artist, whilst she was installing art work. They would get told not to bring packed lunches into the café and get kicked out because they couldn't afford to buy anything. And the essay folded in how art *was* transformational for them as a working class person, but only because it was so integrated into their life with their mother who was an artist, whereas the kinds of social projects, outreach and engagement projects, are often really interesting but in many galleries are insulated from the rest of the structure of the gallery. So I think this is really interesting in terms of transformational-*ness*, also why it's interesting to find out about audiences at the time to see how this works, how many people's lives were transformed by going to these exhibitions, say this one in the '80s, or who at least had an intervention, etc, etc. Which is not to say that I don't think that there's an important place for 'art of intervention' or things in exhibitions which try to transform either.

JG: Iain, I think we might require some further thoughts on how has this

pandemic affected our understanding that we're in a very precarious position here with all art institutions. How is Covid making us rethink?

IM: I feel like Janette went there slightly with her comment about this extra time given to find the thing we haven't found yet. I suppose maybe by extension, what's the thing we haven't found out that we haven't found yet?

JG: I think the point is that we're in this state of hiatus, we're now in this position that we've often dreaded of so-called emergency measures. There is a feeling that we're between things, but we're not. This is actually real life. Looking forward to the Fruitmarket reopening, it's going to have to clear its throat in a completely different way.

IM: I don't know if this is quite the response you're looking for but you've made me think that one of the experiences of layering work in the archives onto this suspended reality has been a shuffling of times, so that many times seem to be simultaneously present. Whether it's through that thing that happened where everyone started reconnecting with old friends at the start of lockdown, or literally trying to recover personas and voices from traces in the archive or writing, or in the way that I noticed in Tom's work that he would often bring in artists who've shown or have connections with the gallery who might be not physically represented there but we're finding them in the penumbra of the activities. So maybe there's this suspended hanging mobile? But I'm struck by what you said about clearing the throat, Jane, because I wonder how we do move from that state of suspension and the ability to see things, into action? I can see Janette's saying something.

JA: We close our eyes, and we open our third eye. And we clear our throat chakra. You're all laughing at me!

IM: Don't laugh at the serious wisdom!

JA: [laughter] That's it. That was my wisdom.

IM: Anyone else want to come in on that question?

CG: Yes, I want to say something which is that I like clearing the throat as a metaphor for it, but I also think that we don't have to be so quick to get it over with. I've been thinking a lot recently about other periods in history that might parallel this one in a way. Lots of people have made this observation, but in the 1918 Spanish Flu pandemic very little art is made about the pandemic because people just wanted it to be over and to get on with life. You think about the enormous amount of art that's made about the First World War, and then

immediately after it, or overlapping with the end of it, there's the Spanish Flu pandemic, and nobody wants to talk about it, everybody just wants to get it over with.

And I also remember as a child hearing a story that in the years immediately following the potato famine in Ireland people would sit around and what they would tell stories about would be 'the great wind' a hurricane that happened a few years before the famine, because they didn't want to talk about the famine because it was so bad and bleak that people felt that it was beyond their capacity to tell stories about it. Likewise with the Spanish Flu people felt that it was beyond their capacity to make art about it or that they didn't want to dwell, to live in that place. I'm not here to say, 'Right everybody stop thinking about the future and all the nice holidays you're going to go on when this is over'. Because you know, we often need that to get through the day or get through the week or get through the month or get through the Zoom meeting or whatever. At the same time, there *is* something to learn about. In my head I think of it as 'plague method' or 'plague study'; there's something that is possible to do at this moment that we shouldn't be too eager to abandon by the side of the road as no longer necessary because (a), this is not going to be over tomorrow and (b), even when it is, everything that has happened will still be with us.

TP: I'm ready to come out now. I've read the big books. And I don't know, I'm feeling that there's a change – well obviously there's a change in the world – but a change within myself and I don't really know what that is yet, but it's interesting. I was affected by the Covid thing through the *Writers' Shift*, but also I was affected by Brexit. Both of these have reduced our world. And I did feel very much before Covid struck that what I wanted to do in *Writers' Shift* was to use the Fruitmarket as a way of looking out into the world. So I went from the building into the neighbourhood and out into the world, particularly to European artists and writers.

JA: I love how you did that Tom. This was your focus, and then you reached out from the navel and then thought, 'Where does that touch the exterior? And how can I bring that back in? And then what does that say when I toss that back out?' And you always did this wonderful process that I completely admired in the way your perspective is so multi-dimensional, it's fantastic.

IM: Definitely. It's been a fascinating year. If we were going to pick a year to sample with this project, blimey, there's been a lot to see refracted through all of your writing. When we work out how to bring it to a wider audience through publication, I think it will be interesting for people in the future to trace the shocks and lights through what you've all done.

Notes and Sources

Unless stated otherwise, exhibitions or events referred to in poem titles took place at the Fruitmarket.

Jane Goldman (pp.62–105)

ARCHURBACK

W.B. Yeats, 'The Second Coming' (1919), in *Michael Robartes and the Dancer* (1921).
Andy Wightman, *The Poor Had No Lawyers: Who Owns Scotland and How They Got it*, Birlinn, 2015.

THE MANIFESTATIONS OF THE OBSESSIONS AND FANTASIES OF BRUCE LACEY AND JILL BRUCE IS A SOLO EXHIBITION BY BRUCE LACEY

Richard Calvocoressi, 'Eye to Eye', *Art Monthly*, December 1979, pp.21–22, REWIND: http://uodwebservices.co.uk/documents/Tamara%20Krikorian/TKR001.pdf
Tom Day, 'Research Summary for Fruitmarket Archive Project: 'Coming into View: A History of Film and Video Art at the Fruitmarket Gallery', August 2019, Fruitmarket Airtable.
Jacques Derrida, 'Archive Fever: A Freudian Impression', trans. Eric Prenowitz, *Diacritics* 25. 2 (Summer, 1995), pp.9–63.
'Maddening the Subjectile', trans. Mary Ann Caws, *Yale French Studies* 84: *Boundaries: Writing & Drawing* (1994), pp.154–71.
Fruitmarket, 'Fruitmarket Exhibition History' (2019–2021), Airtable: https://airtable.com/shrU5T95QTXtCZ5zD/tblsoz28loGFry4ln/viwZngDoEkAy5mTXJ?blocks=bipGjc8p8TnyzEiv5
Elke Krasne, 'Curatorial Materialism. A Feminist Perspective on Independent and Co-Dependent Curating', *ONCURATING.org* 29, May 2016: https://www.on-curating.org/issue-29-reader/curatorial-materialism-a-feminist-perspective-on-independent-and-co-dependent-curating.html#.YDgH_137St8
Tamara Krikorian, *Vanitas*, SD video, 1977: https://lux.org.uk/work/vanitas
'statement written by the artist on *Vanitas*, single-screen installation', REWIND: http://www.rewind.ac.uk/rewind/index.php/Database.
'statement by Krikorian on the work *Tableau*, exhibited at The Fruitmarket Gallery, Edinburgh, 1979', REWIND: http://uodwebservices.co.uk/documents/Tamara%20Krikorian/TKR042.pdf
Jonathan Sale, 'Through a Mouth Darkly', *The Times*, Thursday 5 June 1975, p.14.
Jill Smith, *The Gypsy Switch and Other Ritual Journeys*, Antenna Publications, 2019.
Mother of the Isles, Dor Dama Press, 2004.
The Callanish Dance, Capall Bann, 2000.
Personal correspondence between Jill Smith and Jane Goldman, 2020.
Nancy Spero, Artist's Statement, 'Nancy Spero', Exhibition Leaflet, The Fruitmarket Gallery, 1987.
Alice Tarbuck, *A Spell in the Wild: A Year (and Six Centuries) of Magic*, Two Roads, 2020.
Virginia Woolf, 'Anon' and 'The Reader', *The Essays of Virginia Woolf*, 6 vols, ed. Andrew McNeillie (vols 1–4) and Stuart N. Clarke (vols 5–6), Hogarth Press, 1986–2011, vol. 6.

Iain Morrison (pp.108–127)

2 workshop poems

These were written at Ayachi's and Gardner's workshops for Fruitmarket staff on 22 July and 5 August 2020 respectively. **i)** works from an image of Janet Cardiff & George Bures Miller's *The House of Books Has No Windows*, 31 July – 28 September 2008. **ii)** works from the Fruitmarket's archival material from our Cai Guo-Qiang event *Black Rainbow*, 29 July 2005.

Tom Pow (pp.130–153)

CONVERSATION

This owes a debt to Miroslav Holub's poem, 'Conversation with a Poet', which begins:.

Are you a poet?
 Yes, I am.
How do you know?
 I've written poems.
If you've written poems it means you were a poet. But now?
 I'll write a poem again one day.
In that case maybe you'll be a poet again one day.

PORTRAIT IN LIGHT
'We belong to all countries', Michel de Montaigne
'The local is the universal minus the walls', Miguel Torga

MASONRY
Soon after the project began, I went to the Venice Biennale. I drew on two sources for 'Masonry'.
The first were photographs I took of details within the Fruitmarket extension and details within Venice
itself. I also made use of quotations from artists who have exhibited in the Fruitmarket and from artists
at the Biennale in 2019. As follows:

In '1. Fruitmarket' italics are quotations from Dieter Roth, the idea of landscape moving through you
and the flower names come from Tania Kovats' *Meadow* (2007).
In '2. Venice', 'unfinished conversations on the weight of absence' was the title of the Romanian Pavilion
at the Biennale.

NEON 1 and NEON 2
These are the result of a *Writers' Shift* group conversation on the possibility of neon signs or projections
on the external Fruitmarket wall.

'I love it here!' A FOUND POEM OF FEELGOOD FLUFF TO LET YOUR EYE FLOAT OVER
This poem is composed of very selective visitor comments from Louise Hopkins' exhibition at the
Fruitmarket, 8 October – 11 December 2005.

Antoni Tàpies answers the question –
IN WHAT WAY DO YOU THINK ART IS USEFUL TO SOCIETY?
The lineation here is mine. From 'A Conversation with Antoni Tàpies' Manuel J. Borja Villel Barcelona,
September 1995 (Antoni Tàpies: *New Paintings*, PaceWildenstein, New York)

THE FRUITMARKET COMMUNITY GARDEN
The main poetic forms here are the kotabagaki, tanka, haiku and choka.
The dimensions of the Fruitmarket roof garden are 27m x 15m. I am most grateful to gardener Vicky
Galbraith, who enthusiastically joined me in a conversation about roof gardens and gave me a design
on which I drew for the diary. Edinburgh's Nor' Loch was drained in the 19th century and became
Princes Street Gardens.

BRICKS AND MORTAR
The fifth line is from 'Ghazal: Change of Heart' by Janette Ayachi and it is where this ghazal began.
The phrase 'craving dedication for change' is also from 'Change of Heart'.
The fourth couplet is from the Scottish Government/NHS Scotland advice booklet on Coronavirus.
'Nothing is random; nothing goes to waste' is from 'Courtyards in Delft' by Derek Mahon
'Grant me / Paradise in this world; I'm not sure I'll reach it in the next' is a quotation from Tintoretto.

CRANES
This is the first poem that I wrote for the project – feeling my way for the context within which the
Fruitmarket stands. Over the weeks of lockdown, I have had lots of occasions to appreciate the heron on
the River Nith.

MASONRY and **BRICKS AND MORTAR** were both first published in NARANJAS by Tom Pow,
Galileo Publishing, 2021.

Ruth Bretherick
Archival ebbs and flows (pp.170-172)
1. Recent such projects include artist Walter van Rijn's work for John Hansard Gallery's exhibition *Time
 After Time* (2018), or Modern Art Oxford's project 'Activating our Archives' led by Sunil Shah (2019).
 These were both discussed during a Plus Tate study day we organised called 'Archiving the
 Contemporary', hosted by BALTIC Centre for Contemporary Art (Gateshead) in July 2019.
2. 'Writers' Shift at The Fruitmarket Gallery', *Gutter Magazine*, September 2021,
 https://www.guttermag.co.uk/blog/writersshift [accessed 30 Nov 2021].

3. Ibid.
4. While the Fruitmarket was founded in 1974, the materials we hold date from the beginning of the directorship of Mark Francis in 1984.

Hidden Archive, 18.11.20. Transcription of Shola von Reinhold's response to the Fruitmarket's archive (pp.176–180)

1. Von Reinhold frames their response at this live event as 'given from a mix of notes and extemporisation'.
2. Shola von Reinhold, *LOTE*, (Jacaranda Books, 2020).
3. Anjalie Dalal-Clayton, *Coming into View: Black British Artists and Exhibition Cultures, 1976–2010* (2015)
4. The Other Story was an exhibition held from 29 November 1989 to 4 February 1990 at the Hayward Gallery in London.
5. *Writing in the Absence of History*, hosted by the White Review on 28 October 2020.

Hidden Archive, 18.11.20. Transcription of Conversation between Writers' Shift Poets (pp.182–189)

1. See Roger Fry, 'Negro Sculpture at The Chelsea Book Club', Vision and Design, London: Chatto & Windus, 1920; Lois J. Gilmore, '"But somebody you wouldn't forget in a hurry": Bloomsbury and the Contradictions of African Art', Contradictory Woolf: The Selected Papers from the Twenty-First Annual International Conference on Virginia Woolf, ed. Derek Ryan and Stella Bolaki, Clemson: Clemson University Press, 2012.
2. 'THE MYTH OF "TRANSFORMATIVE" ART AND THE REALITY OF ART AS PART OF EVERYDAY LIFE – GUEST BLOG' Rosie Priest, October 2, 2020. https://colouringinculture.org/blog/the-myth-of-transformative-art/

BIOGRAPHIES

Janette Ayachi is based in Edinburgh, born in London, with Scottish & Algerian heritage. She's a regular on BBC Scotland arts programmes & has published work in a broad range of anthologies including from presses such as Seren; Jessica Kingsley London, Canongate & Polygon. Her debut poetry book *Hand Over Mouth Music* (Pavilion) won the Saltire Poetry Book of the Year Literary Award 2019. She collaborates with artists & performs her poetry at festivals & events. Currently she is working on writing her second poetry collection *QuickFire, Slow Burning* (Pavilion) & publishing her memoir *Lonerlust* which chronicles her journeys travelling alone searching landscapes, culture, desire & human connection.

Callie Gardner was a writer from Glasgow, active across publishing, teaching and organising. *Zarf*, the poetry magazine they edited from (2015–2020) also existed as a pamphlet press, Zarf Editions. At Glasgow queer bookshop *Category is Books* they hosted a regular poetry workshop. *Naturally It Is Not: A Poem in Four Letters* was published by the87press in 2018. *We Want It All: An Anthology of Radical Trans Poetics* (Nightboat Books, 2020) included several of their poems and much of their poetry and criticism is available online, linked from their website 'misleadingly like lace'.

Jane Goldman lives in Edinburgh and is Reader in English at the University of Glasgow. She likes anything a word can do. Her poems have appeared in *Scree, Tender, Gutter, Blackbox Manifold, Adjacent Pineapple* and other magazines, and in the pamphlet, *Border Thoughts* (Sufficient Place/Leamington Books, 2014). *SEKXPHRASTIKS* (Dostoevsky Wannabe, 2021) is her first full length collection.

Iain Morrison is a poet, performer and programmer based in Edinburgh. His book *I'm a Pretty Circler* was shortlisted for the Saltire Prize in 2019.

Tom Pow was born in Edinburgh in 1950. Highlights from his extensive publishing include *In Another World – Among Europe's Dying Villages* from Polygon in 2012, and his latest collection *Naranjas* published by Galileo Publishers in 2021.

Shola von Reinhold

Shola von Reinhold is a writer born and based in Glasgow. Shola's first novel *LOTE* was published in 2020 and subsequently won the Republic of Consciousness Prize and James Tait Black Prize.

Acknowledgements

Writers' Shift

Published by Fruitmarket
45 Market Street, Edinburgh, EH1 1DF
Tel: +44 (0)131 225 2383
info@fruitmarket.co.uk
www.fruitmarket.co.uk

Distributed by
Art Data, 12 Bell Industrial Estate
50 Cunnington Street, London W4 5HB
Tel: +44 (0)208 747 1061
www.artdata.co.uk

ISBN: 978-1-908612-61-8
© 2022 Fruitmarket, the artists, authors
and photographers.

p.25, p.45, p.61, p.107, p.129: photos by Chris Scott.

The Fruitmarket Gallery is a company limited by
guarantee, registered in Scotland No. 87888 and
registered as a Scottish Charity No. SC 005576

VAT No. 398 2504 21

Registered Office:
45 Market Street, Edinburgh, EH1 1DF

Poets' thanks

Janette Ayachi
This has been such a powerful collective,
deep gratitude to all that made it possible.

Jane Goldman
Iain Morrison and fellow Writers' Shift poets,
Tom Day, archivist, the staff of the Fruitmarket,
the John Chamberlain Estate, Holly Argent,
Louise Dick, Lorna Hepburn, John Kirkwood,
and Jill Smith.

Iain Morrison
Fiona Bradley for instigating the *Writers' Shift*
and many other welcome shifts; his fellow
Shifters for the best shared writing adventure;
Shola von Reinhold an especial thanks for
willingly joining us in media res, and the Scottish
Book Trust for funding their contribution;
Tom Day, Ruth Bretherick and all colleagues
at Fruitmarket for participating in the sessions
and supporting the project in many acts;
Elizabeth McLean and Susan Gladwin for
finding the right design for this book;
Mark Reilly and Jane Goldman for listening
to the introductory essay in multiple forms;
and all the artists without whom nothing would
have been built.

Tom Pow
With thanks to the Fruitmarket for the
opportunity to take part in the project
– to Iain Morrison (it has been a pleasure
to be part of Iain's Big Poem) and to the other
Writers' Shifters, Janette Ayachi, Callie Gardner
and Jane Goldman. And with every good wish
for the new gallery.

for Callie Gardner
We are so very sad that Callie is not with us to see
this work come to fruition, but we do know that
they were really pleased to have taken part. They
derived a great deal of meaning and pleasure from
their involvement in the project and would have
been very proud to see the end result. It is a source
of great comfort for us that they live on through
their work. Sumac (Callie's partner), Ruth, Martin
and Iain (Callie's family).

CREATIVE SCOTLAND
ALBA | CHRUTHACHAIL